KB141222

강 홍 구

Kang, Hong-Goo

HEXAGON

이 도서의 국립중앙도서관 출판예정도서목록(CIP)은 서지정보유통지원시스템 홈페이지(http://seoji.nl.go.kr)와 국가자료 공동목록시스템(http://www.nl.go.kr/kolisnet)에서 이용하실 수 있습니다.(CIP제어번호: CIP2017021259)

한국현대미술선 036
강홍구

2017년 8월 31일 초판 1쇄 발행

지은이 강홍구
펴낸이 조기수
펴낸곳 출판회사 헥사곤 Hexagon Publishing Co.
등 록 제 2017-000054호 (등록일: 2010. 7. 13)
주 소 경기도 용인시 수지구 죽전로238번길 34, 103-902
전 화 010-3245-0008, 010-7216-0058, 070-7628-0888
팩 스 0303-3444-0089
이메일 coffee888@hanmail.net, joy@hexagonbook.com
website: www.hexagonbook.com

ⓒ강홍구 2017, Printed in KOREA

ISBN 978-89-98145-89-7
ISBN 978-89-966429-7-8 (세트)

강 홍 구

Kang, Hong-Goo

036

HEXAGON
Korean Contemporary Art Book
한국현대미술선 036

안개와 서리
Mist and Frost

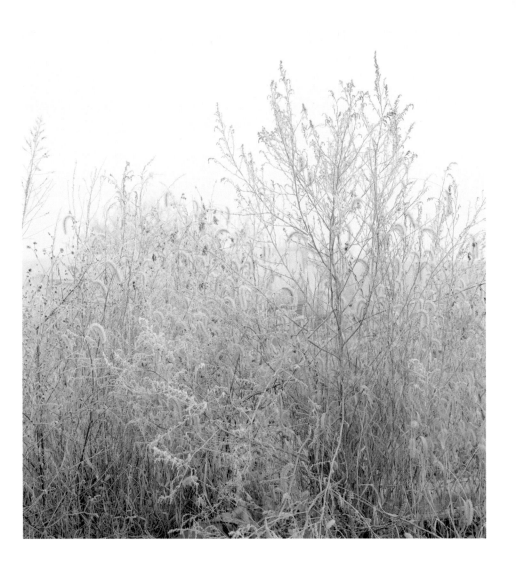

mist and frost 01 80×85cm Digital print 2012

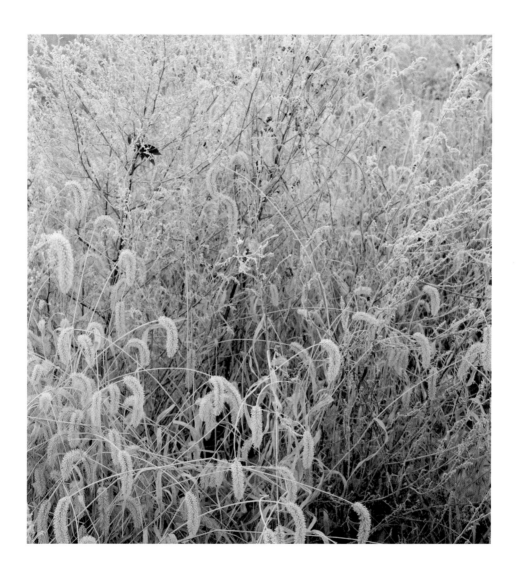

mist and frost 02 80×85cm Digital print 2012

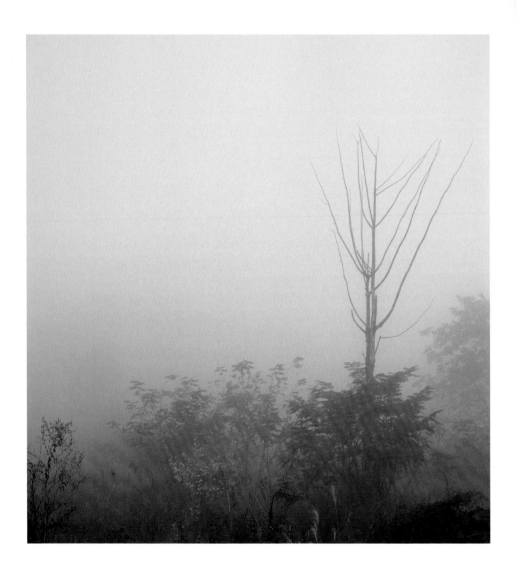

mist and frost 04 80×85cm Digital print 2008

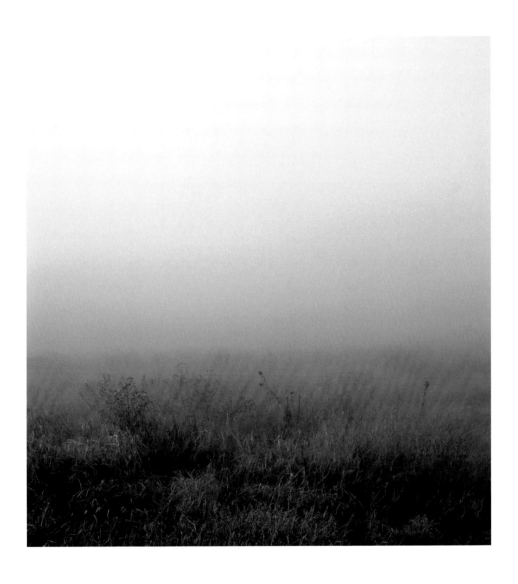

mist and frost 06 80×85cm Digital print 2012

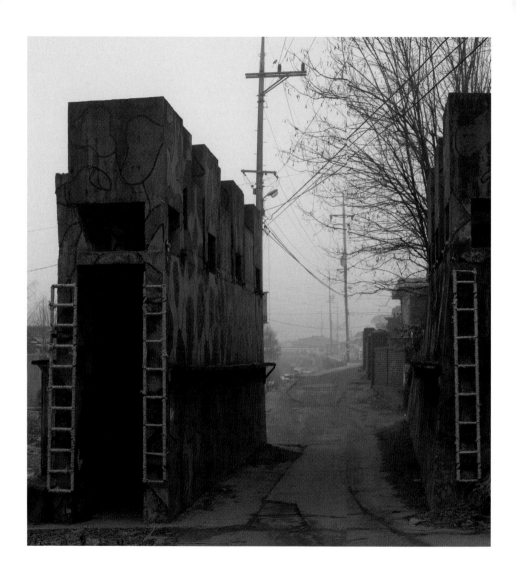

mist and frost 08 80×85cm Digital print 2008

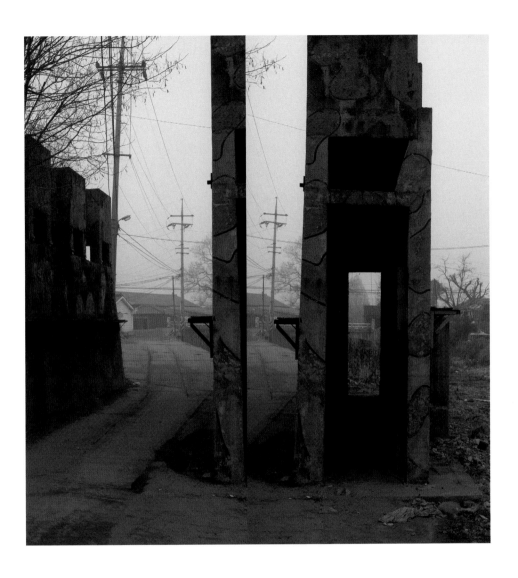

mist and frost 09 80×85cm Digital print 2008

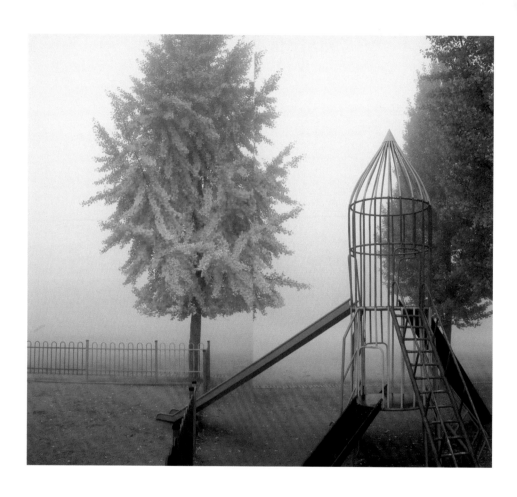

mist and frost 10 100×90cm Digital print 2011

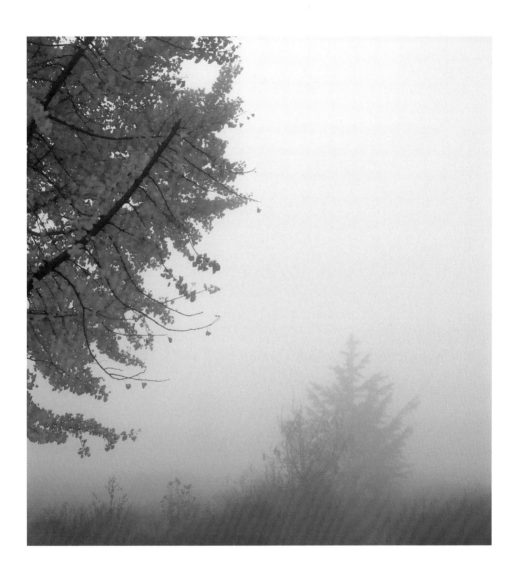

mist and frost 05 80×85cm Digital print 2011

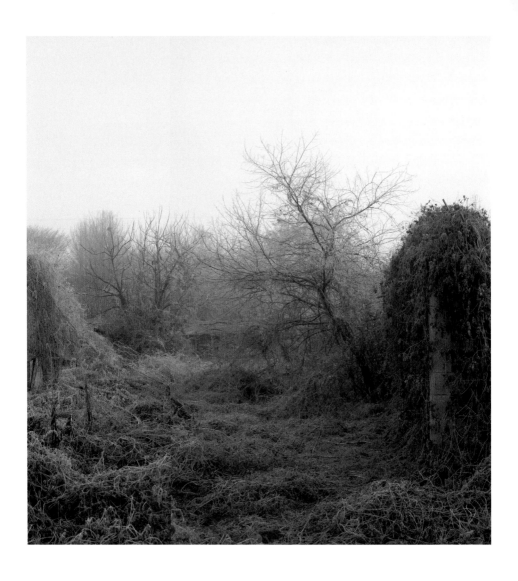

mist and frost 03 80×85cm Digital print 2011

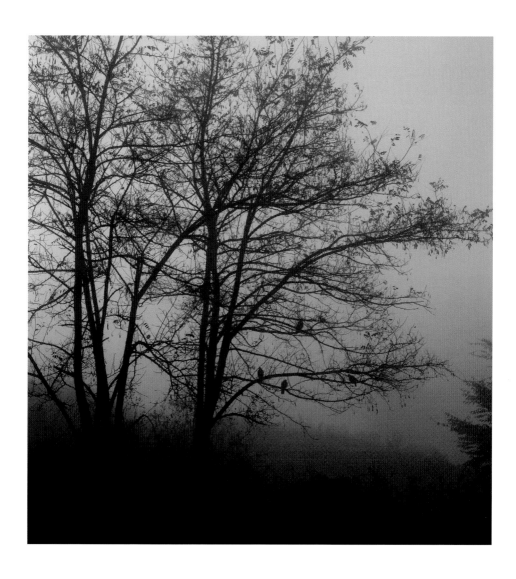

mist and frost 07 80×85cm Digital print 2012

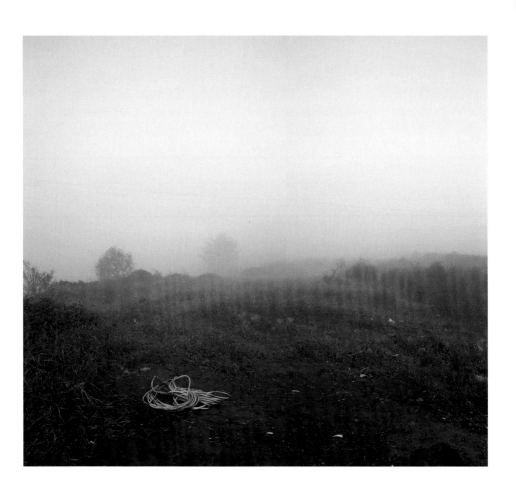

mist and frost 11 100×90cm Digital print 2012

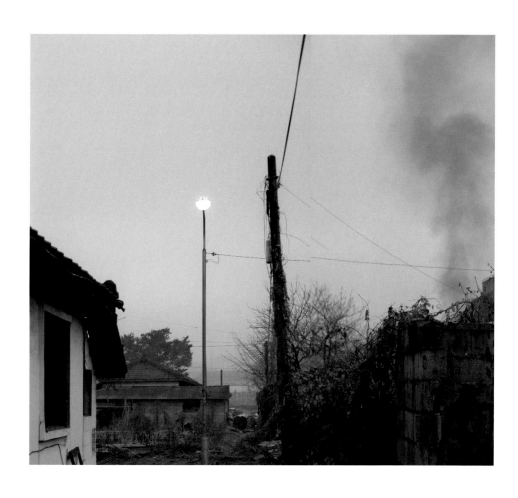

mist and frost 14 100×90cm Digital print 2011

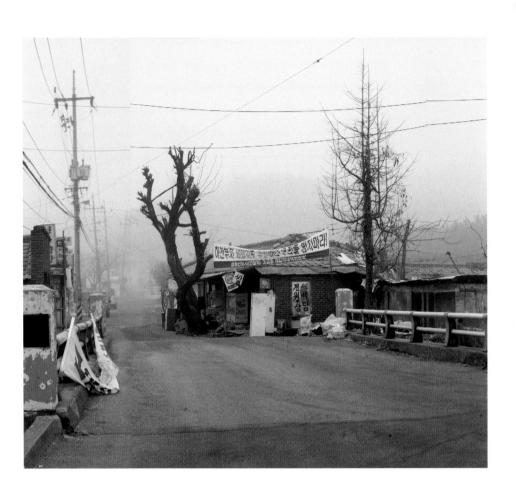

mist and frost 12 100×90cm Digital print 2008

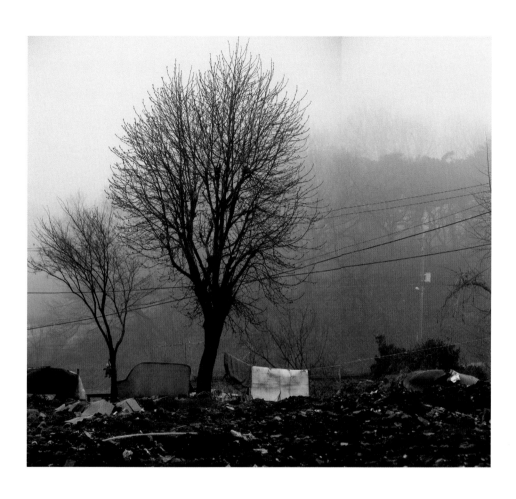

mist and frost 13　100×90cm　Digital print　2014

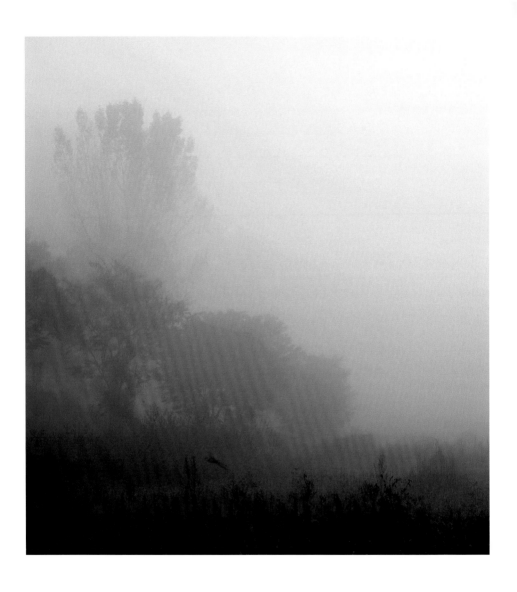

mist and frost 34 80×85cm Digital print 2012

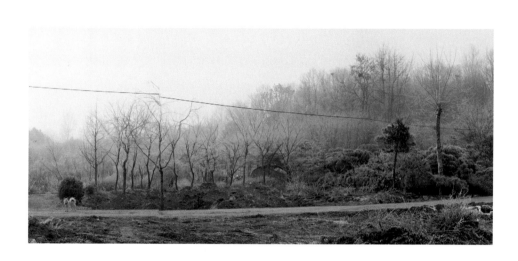

mist and frost 23 100×45cm Digital print 2008

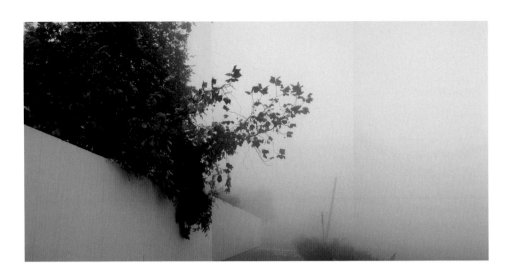

mist and frost 20 160×80cm Digital print 2011

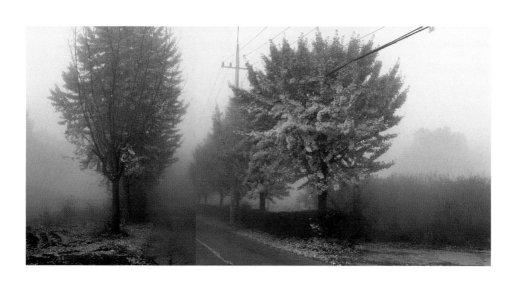

mist and frost 15 160×80cm Digital print 2011

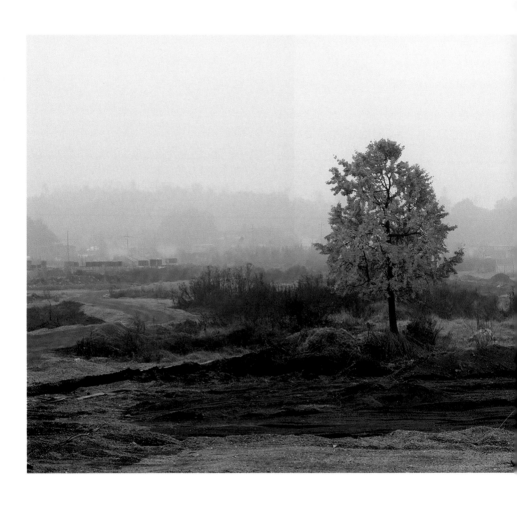

mist and frost 30 220×90cm Digital print 2012

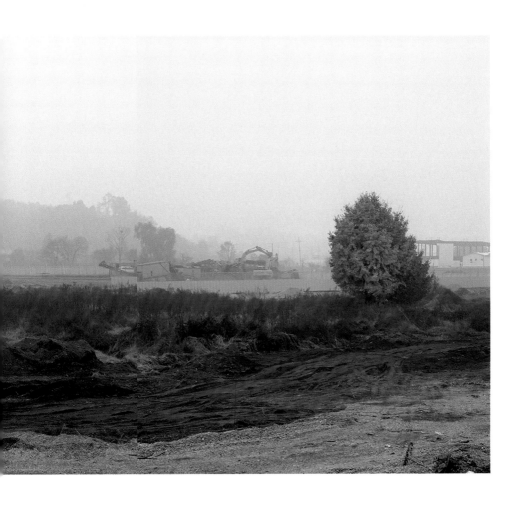

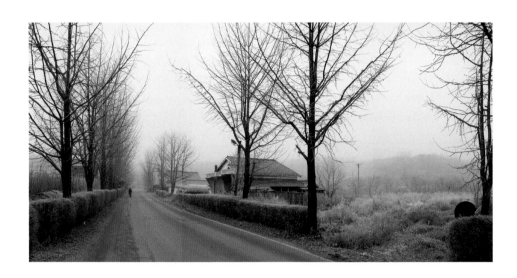

mist and frost 24 160×80cm Digital print 2012

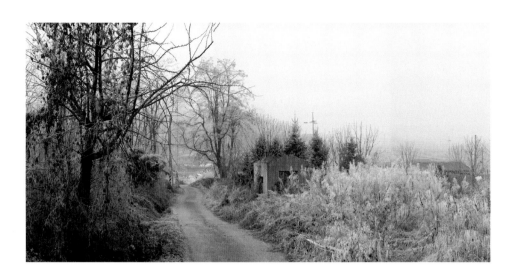

mist and frost 25 160×80cm Digital print 2012

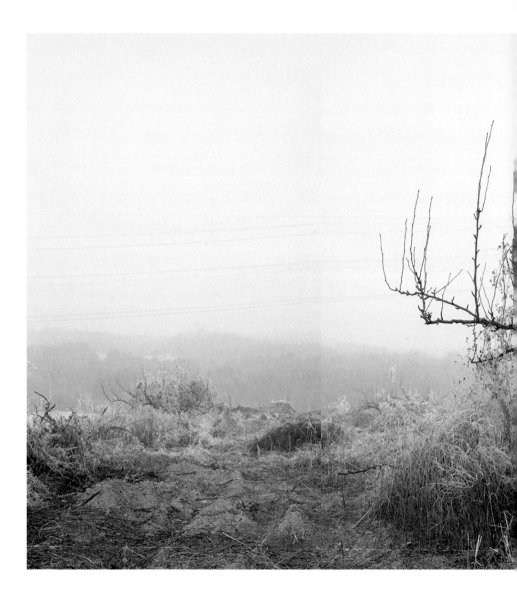

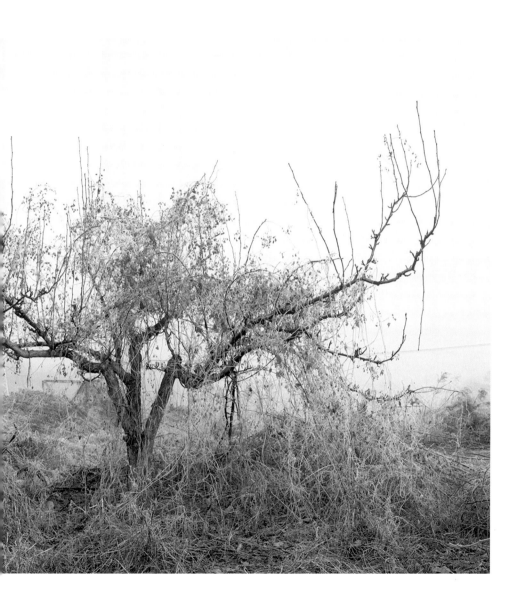

mist and frost 17 160×80cm Digital print 2011

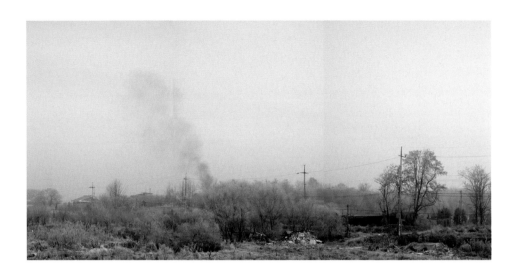

mist and frost 27 160×80cm Digital print 2008

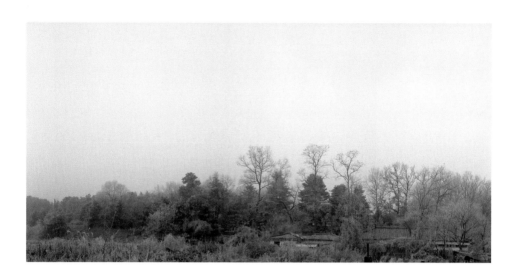

mist and frost 19 160×80cm Digital print 2008

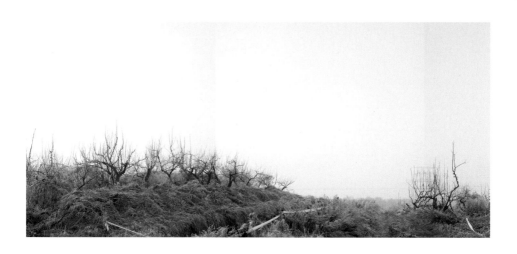

mist and frost 18 100×45cm Digital print 2008

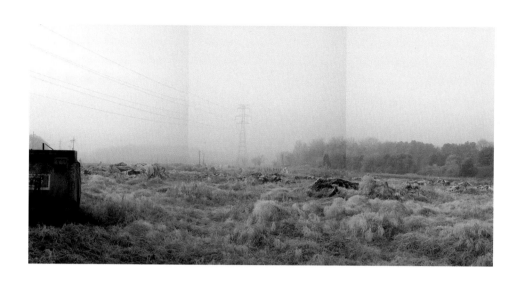

mist and frost 26 180×90cm Digital print 2008

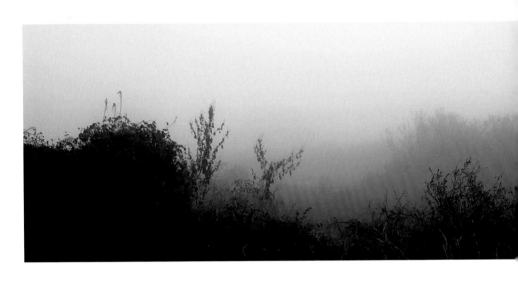

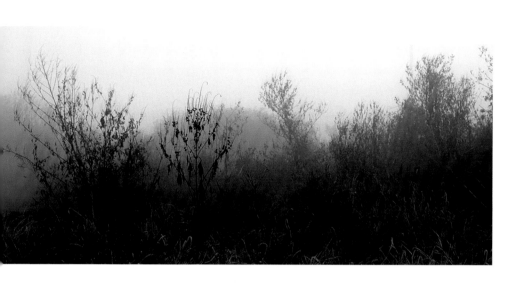

mist and frost 22 180×40cm Digital print 2011

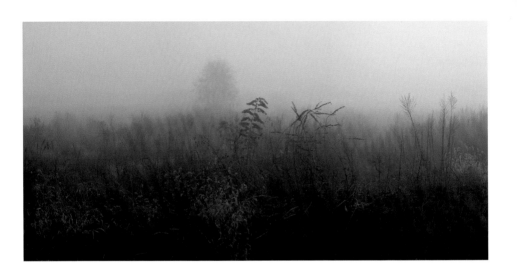

mist and frost 21 160×80cm Digital print 2011

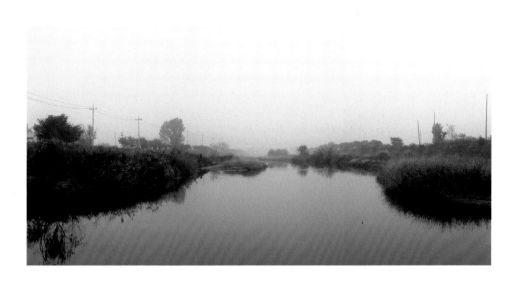

mist and frost 16 160×80cm Digital print 2013

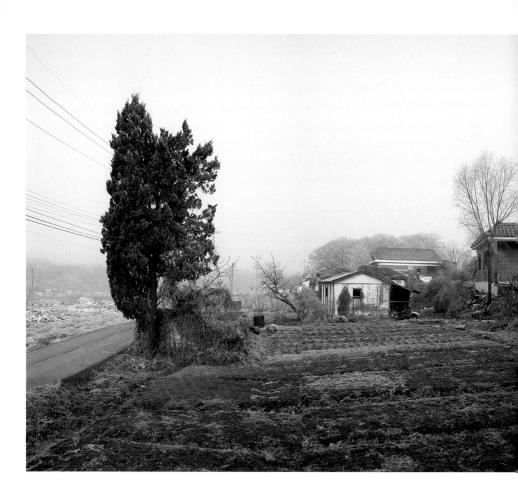

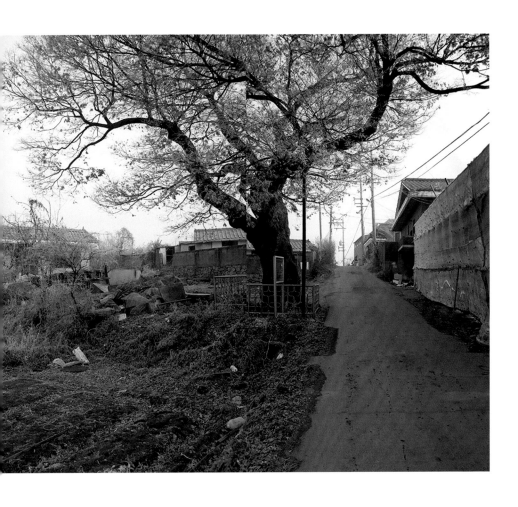

mist and frost 32 220×90cm Digital print 2008

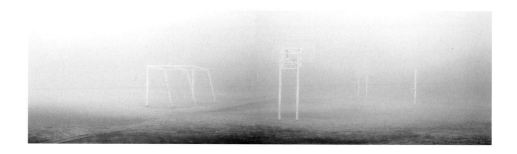

mist and frost 28 100×28cm Digital print 2012

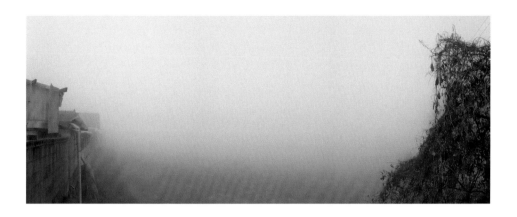

mist and frost 31 160×63cm Digital print 2011

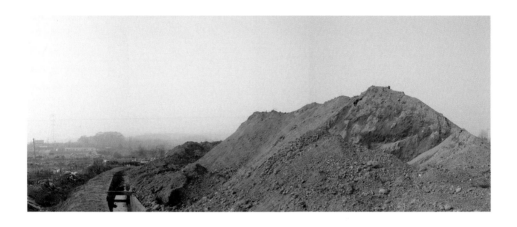

mist and frost 29 100×45cm Digital print 2008

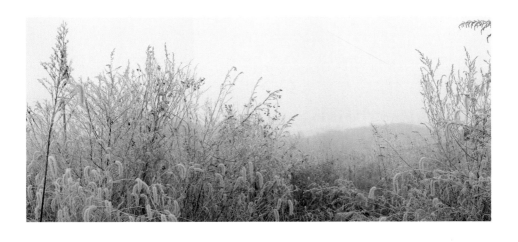

mist and frost 36 140×80cm Digital print 2008

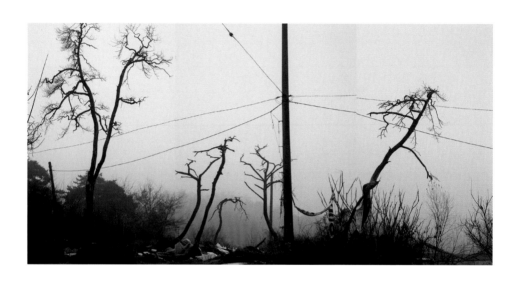

mist and frost 33 160×80cm Digital print 2008

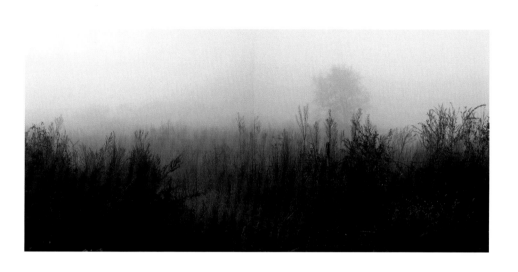

mist and frost 38 200×100cm Digital print 2012

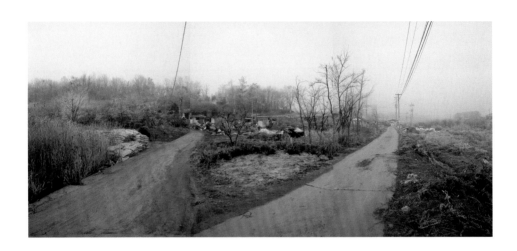

mist and frost 37 200×90cm Digital print 2008

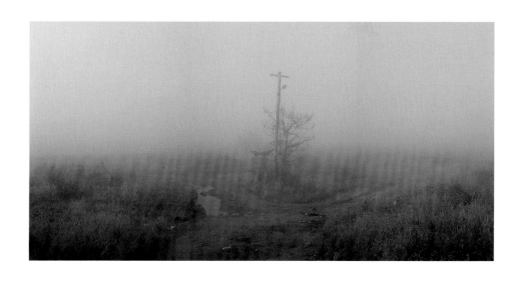

mist and frost 35 160×80cm Digital print 2008

안개와 서리
-10년

2007년 가을 버스를 타고 가다 고양시 오금동과 신원리에 짙게 낀 안개를 보았다. 이 장면은 사진을 찍어야겠다는 생각이 들었다. 버스에서 내려 사진을 찍기 시작했다. 그 뒤 고양시 삼송, 고양, 원흥 지구가 신도시로 개발 되었다. 안개가 낀 날이나 서리가 많이 내린 날은 카메라를 들고 나갔다. 그렇게 10년이 지났다.

그 동안 내가 사진을 찍었던 장소에는 아파트와 빌딩들이 들어섰다. 그곳에 있던 집과 논밭은 흔적도 없이 사라졌다. 나무들과 잡초도 없어졌다. 남은 것은 사진뿐이다. 이 사진들을 어떻게 해야 하나 보고 또 보았다.

안개는 모든 것을 비현실적으로 만든다. 무너진 빈 집, 잡초, 뿌리 뽑힐 나무들, 군사용 시설, 사라질 마을과 학교를 가리지 않는다. 사진도 마찬가지다. 사진이란 일종의 안개이다. 사진 속에 담긴 현실이란 시간이 지나면 서리처럼 녹아 금방 사라져버린다. 안개 같은 분위기만 남을 뿐이다.

이 작업들의 목표는 사진을 현실에서 최대한 멀리 떼어 놓는 것이었다. 그렇게 해도 그 안에 현실감이 남아 있을까. 색과 구도를 바꾸었다. 초겨울의 싸늘한 기운이 느껴지도록 특히 신경 썼다.

만들어진 사진들을 보고 있다 그런 생각이 들었다. 이 사진들이 전부인가? 십 년 동안 나는 뭘 했나? 여러 번의 개인전을 했고, 결혼을 해서 애를 낳아 키웠고, 이사를 다녔고, 어머니가 돌아가셨다. 개인전을 하느라 많은 양의 사진 시험 프린트와 드로잉을 했다. 작품이라고 부르는 것들은 그것들의 일부일 뿐이다.

내가 찍은 사진들은 일종의 풍경의 유령이다. 사진은 그걸 가둬놓는 좀비나 미이라 같은 것이다. 일시적이었고 사라질 운명이었다. 전시도 그렇다. 아무리 애를 써도 그것 이상은 아니다.

작품이 팔릴까? 모르겠다. 안개처럼 사라져 버렸으면 좋겠지만 아니어도 별 수 없다. 지난 시절 동안 안개 속을 카메라를 들고 헤맸고, 몸에는 서리가 내렸지만 견뎠다. 앞으로 20년은 어떻게든 더 버틸 수 있겠지.

Mist and Frost

-10 Years

In the autumn of 2007, I took a bus and observed the mist of Ogeum Dong and Sinnwon in Goyang city. The fog and frost seemed to call to the camera so I was compelled to take photos of the scene so I go off the bus and started to take them. In those days, in Goyang, Samsong and Sonheung districts there was a lot of development to create these new urban developments (the "new cities").

Ten years have passed and in the place where I took the photos stand apartments and buildings. The house and rice paddy fields are gone without a trace as are the trees and weeds. Only the photos remain. I looked at the pictures and asked what I could do with them.

The mist makes everything unrealistic. Empty houses, weeds, military facilities and disappearing villages appear surreal due to the mist. The same is true of photographs. Photography is like a kind of fog. As time goes by, the reality in the photo melts like frost. What remains is a fog engulfed atmosphere.

The goal of these works was to separate the picture as far as possible from

reality. Will a sense of reality remain? I changed the color and composition with a focus on trying to conjure the aura of the early Winter that I felt.

I ask myself what have I done for decades since I took these photos. I have done several solo shows, got married, raised children, moved and buried my mother. I made a lot of photo test prints and drawings for solo exhibitions. What they call work is just a part of them.

The photographs I took are a kind of landscape ghost. The picture is like a zombie or a mummy that locks it up. It was temporary and destined to disappear. So is the exhibition. No matter how hard you try, it is not more than that.

Will the works sell? I don't know but I wish my works would disappear like fog. If they do not there is no other way. In the past, as I was holding the camera to the mist, my body froze because of the frost but I stood firm. I hope I can endure for another twenty years.

언더프린트
Underprint

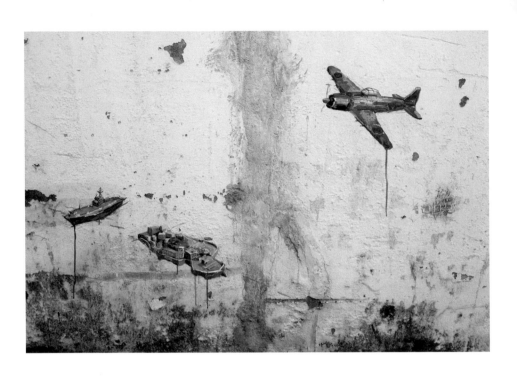

제로센 zero fighter 150×100cm Acrylic on photo 2015

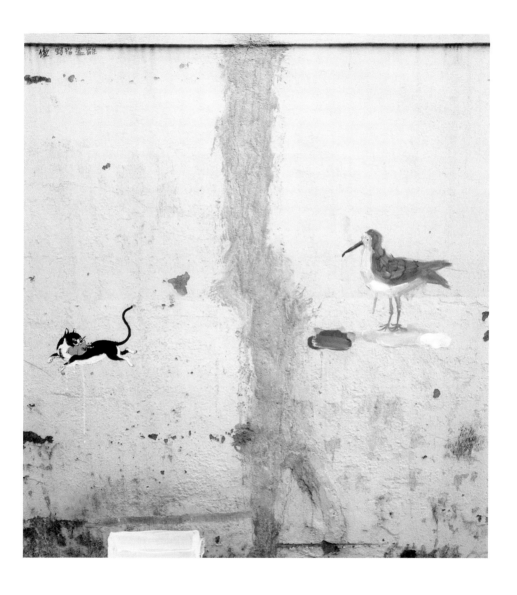

도둑고양이 stray cat 100×110cm Acrylic on photo 2015

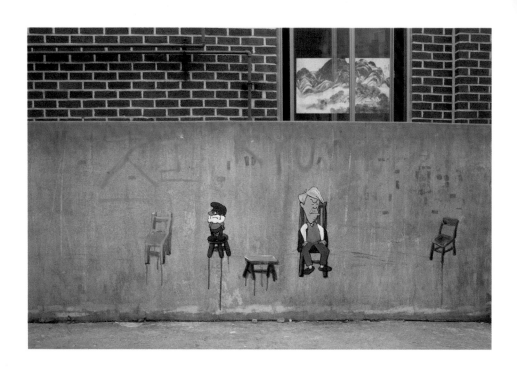

의자 chair 150×100cm Acrylic on photo 2015

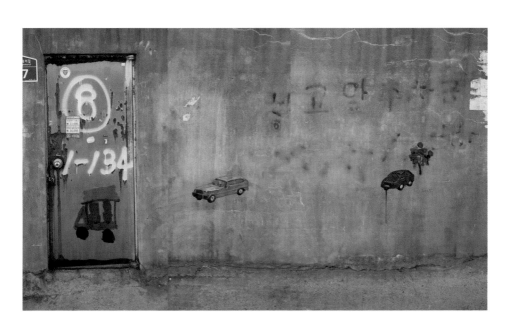

자동차 car 170×100cm Acrylic on photo 2015

참새 sparrow 240×100cm Acrylic on photo 2015

where am I ?

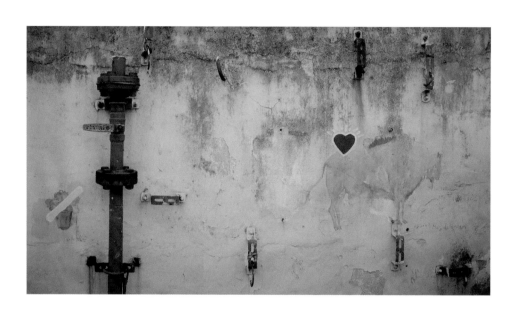

붉은 심장 red heart 180×100cm Acrylic on photo 2016

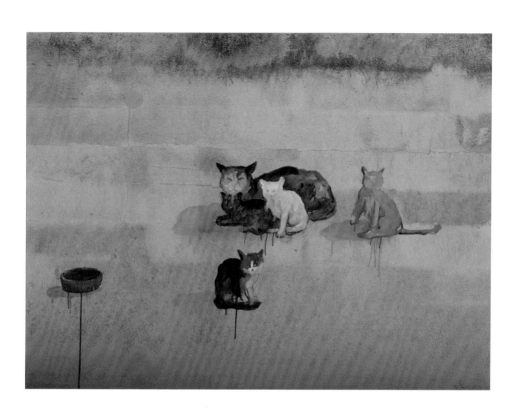

고양이| cat 150×100cm Acrylic on photo 2015

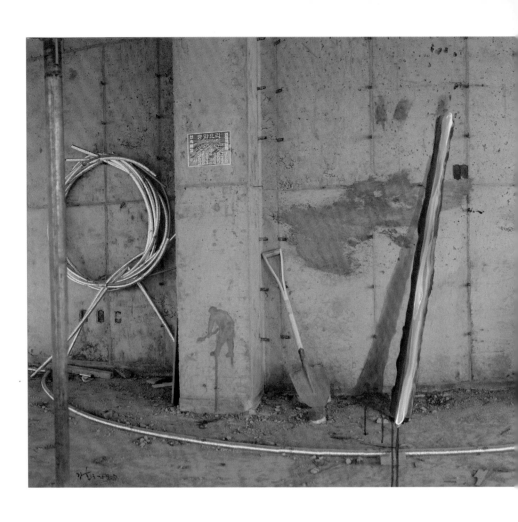

불 fire 240×100cm Acrylic on photo 2015

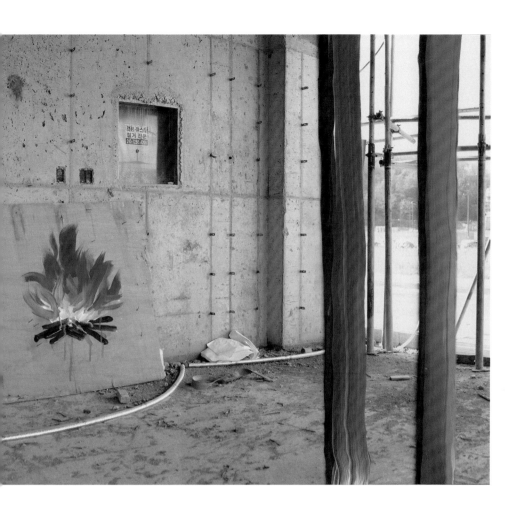

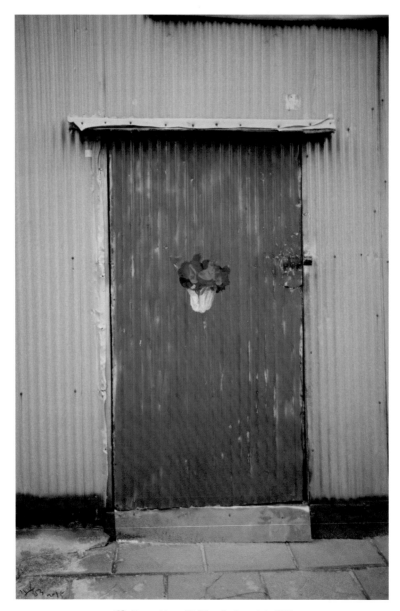

배추 chinese cabbage 45×67cm Acrylic on photo 2015

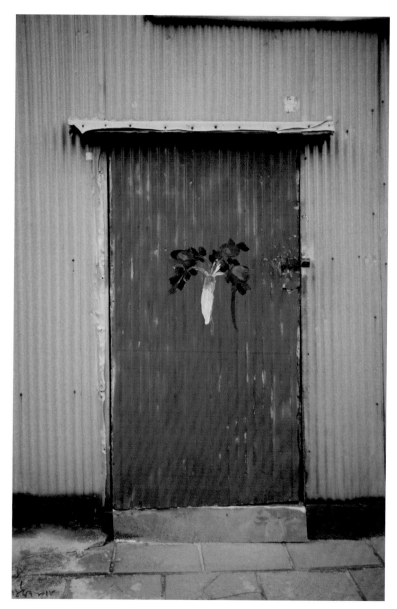

무 daikon 45×67cm Acrylic on photo 2015

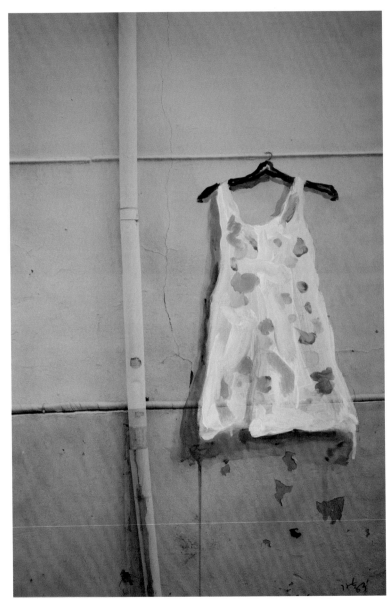

원피스 one-piece 45×67cm Acrylic on photo 2015

감옥 jail 65×100cm Acrylic on photo 2015

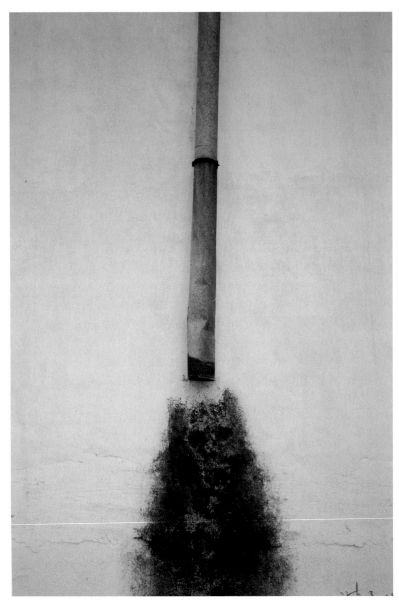

두개골 skull 40×60cm Acrylic on photo 2015

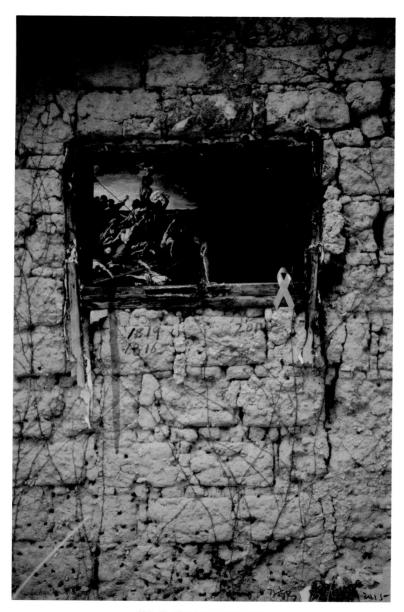

2014 40×60cm Acrylic on photo 2015

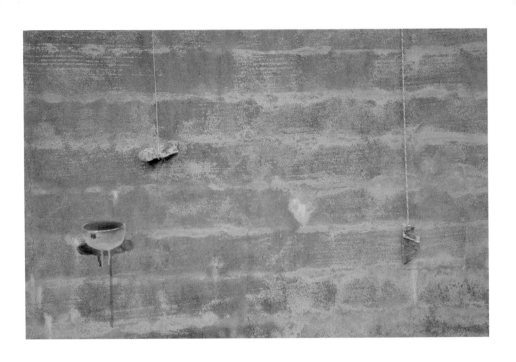

돌 stone 100×65cm Acrylic on photo 2015

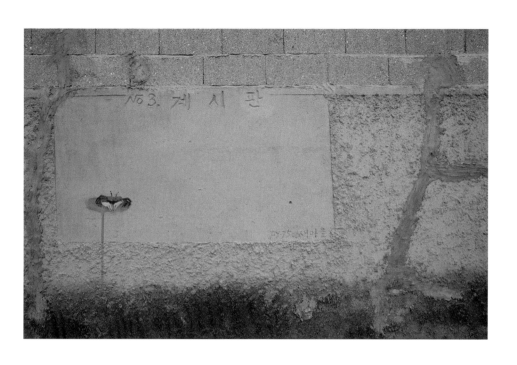

게시판 bulletin board 100×65cm Acrylic on photo 2015

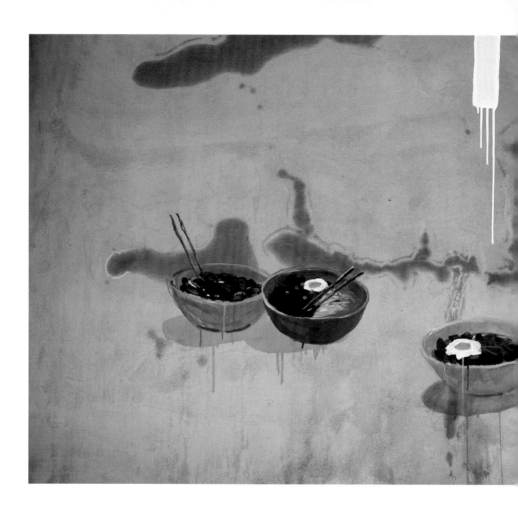

짜장면 jajangmyeon 240×100cm Acrylic on photo 2015

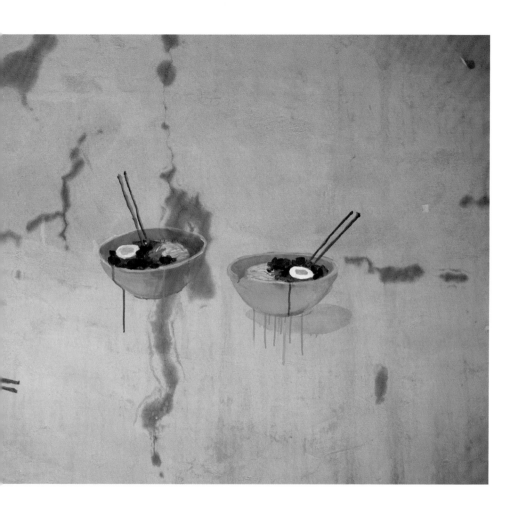

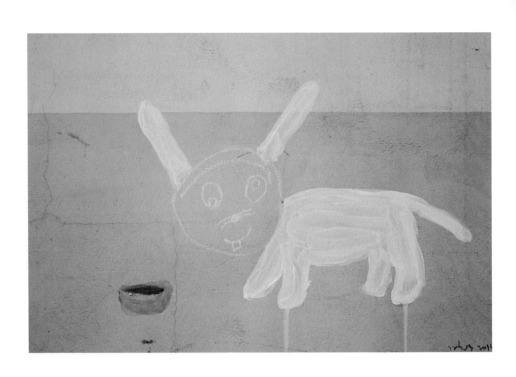

토끼 rabbit 45×30cm Acrylic on photo 2015

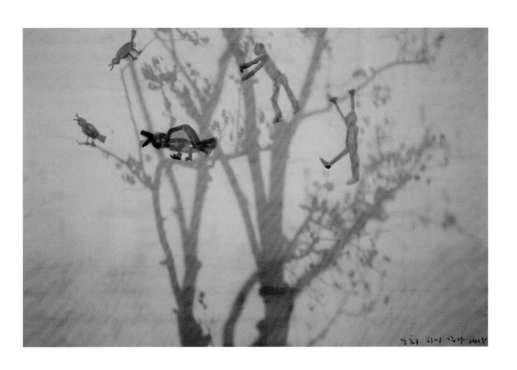

그림자 shadow 60×40cm Acrylic on photo 2015

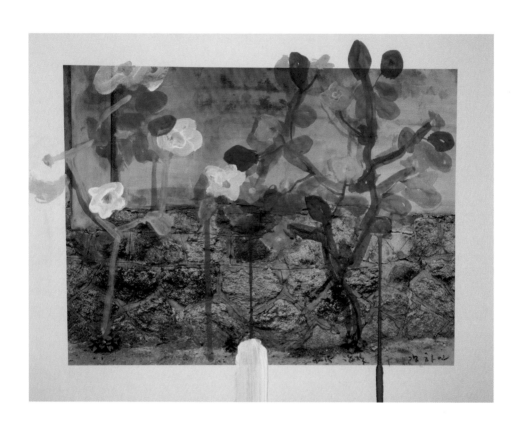

꽃 flower 40×30cm Acrylic on photo 2015

구름 cloud 60×40cm Acrylic on photo 2015

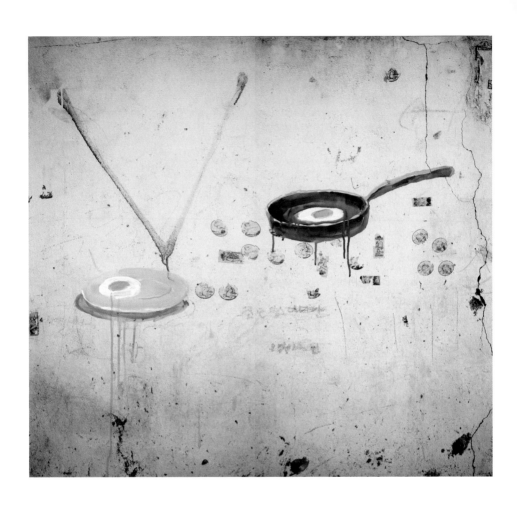

달�걀 프라이 fried egg 110×100cm Acrylic on photo 2015

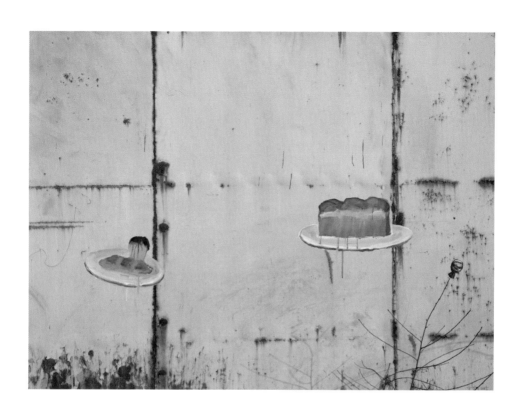

빵 bread 135×100cm Acrylic on photo 2015

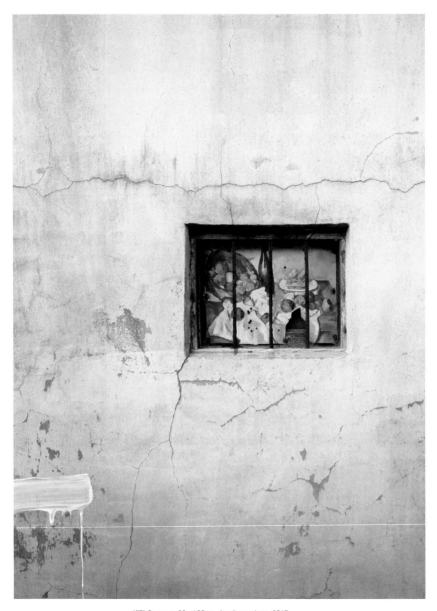

세잔 Cezanne 80×100cm Acrylic on photo 2015

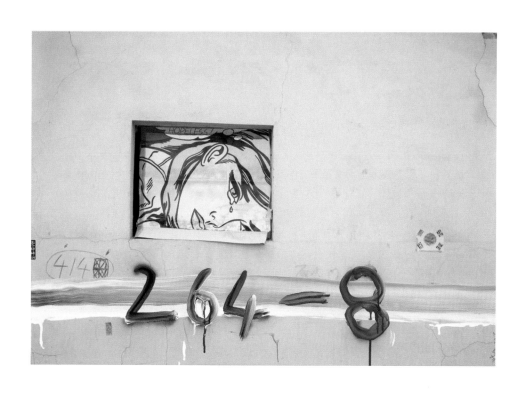

절망 hopeless 100×70cm Acrylic on photo 2015

뭉크 munch 150×100cm Acrylic on photo 2015

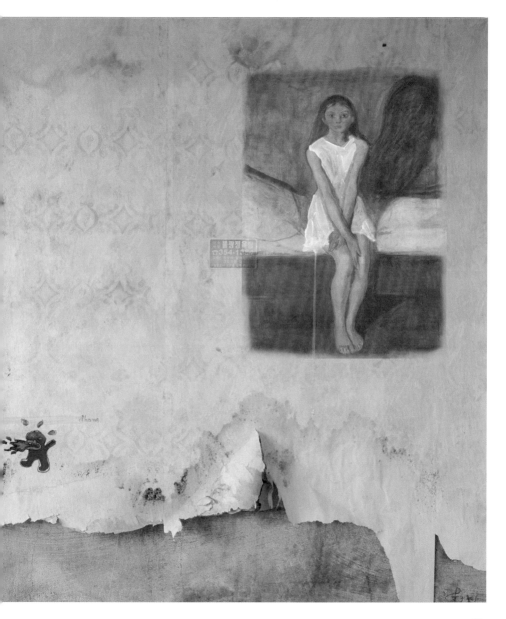

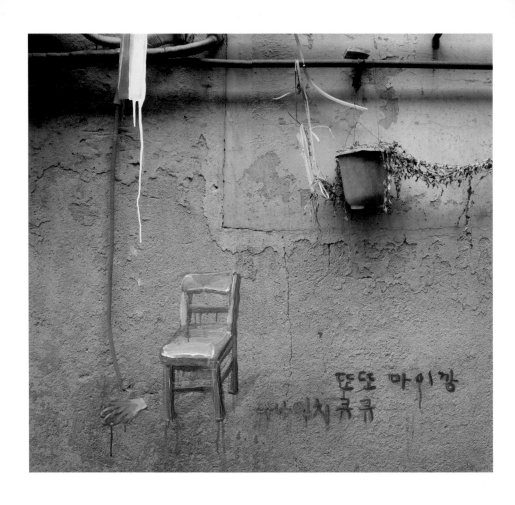

나나인치 nanainch 110×100cm Acrylic on photo 2015

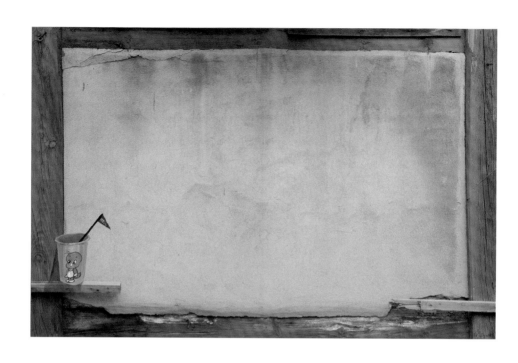

지옥 hell 100×65cm Acrylic on photo 2015

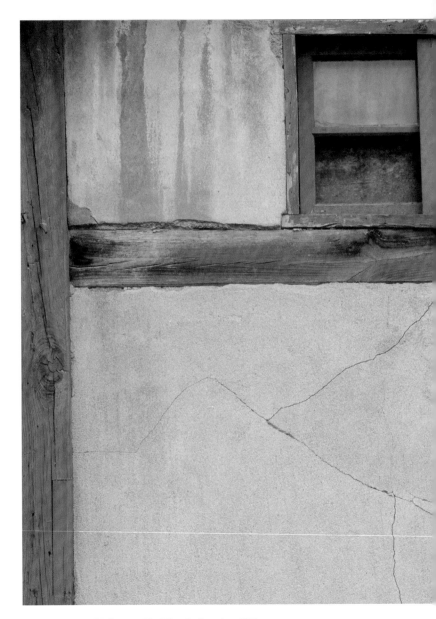

쿠르베 courbet 170×100cm Acrylic on photo 2015

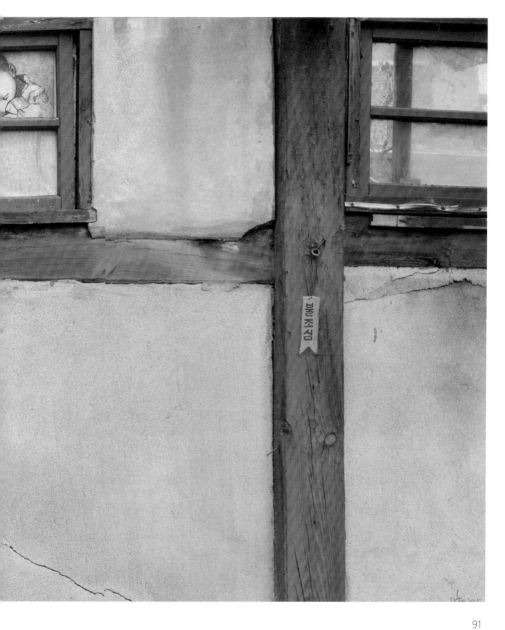

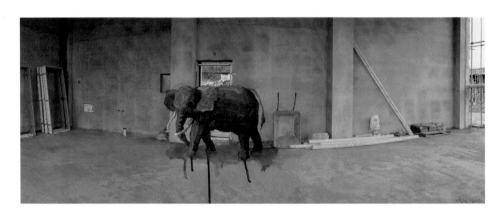

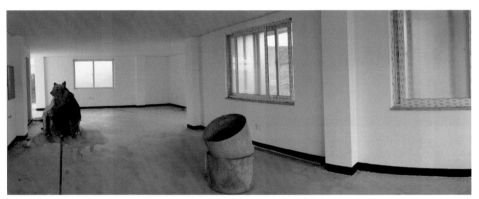

코끼리 elephant 100×35cm Acrylic on photo 2015
곰 bear 100×35cm Acrylic on photo 2015

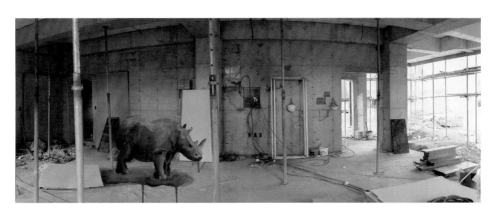

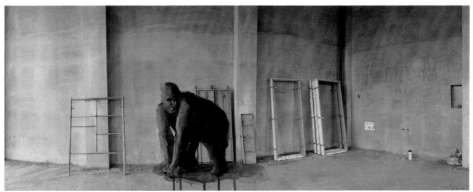

코뿔소 rhino 100×35cm Acrylic on photo 2015
고릴라 gorilla 100×35cm Acrylic on photo 2015

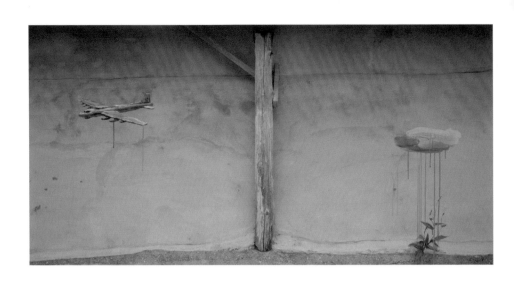

폭격기 bomber 200×100cm Acrylic on photo 2015

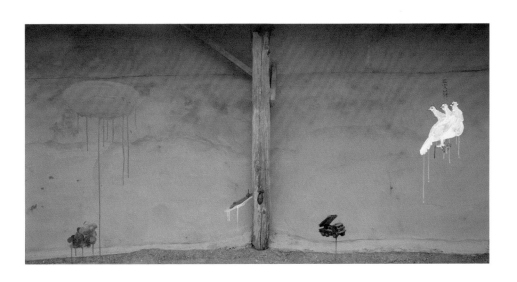

부적 talisman 200×100cm Acrylic on photo 2015

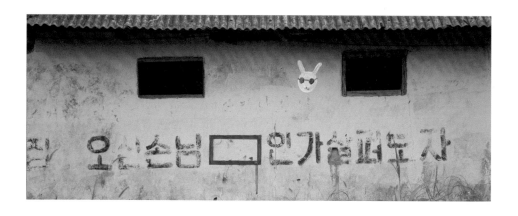

손님 visitor 100×35cm Acrylic on photo 2015

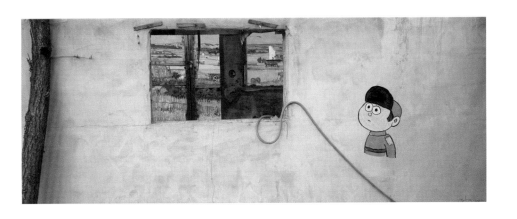

고흐 gogh 100×35cm Acrylic on photo 2015

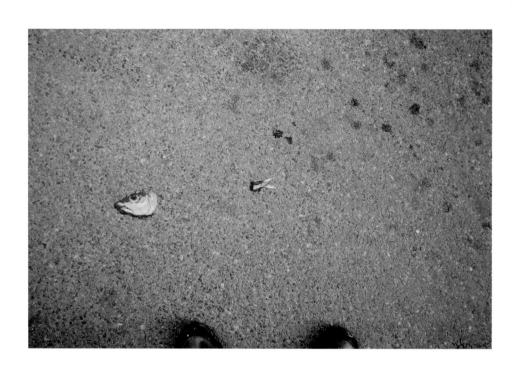

고등어 mackerel 60×40cm Acrylic on photo 2015

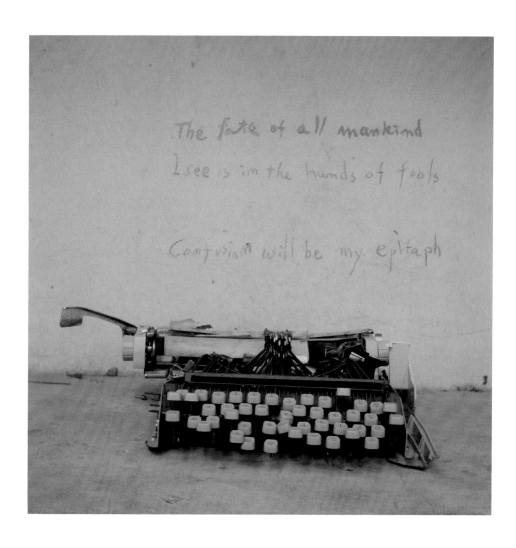

에피타프 epitaph 40×40cm Acrylic on photo 2015

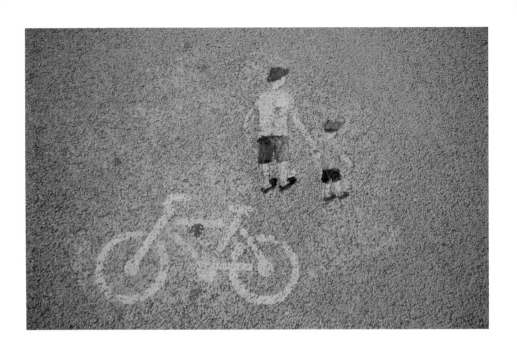

자전거 bicycle 47×30cm Acrylic on photo 2015

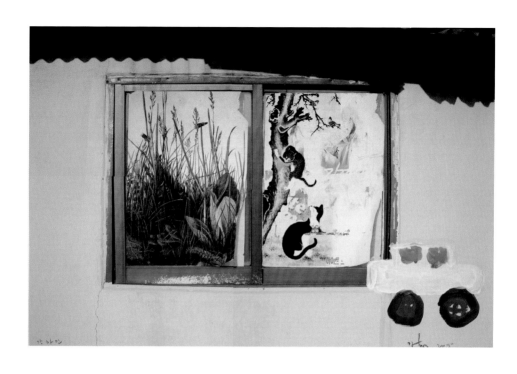

창문 window 60×40cm Acrylic on photo 2015

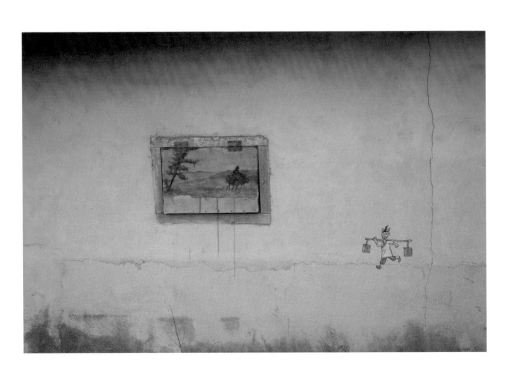

풍경 landscape 150×100cm Acrylic on photo 2015

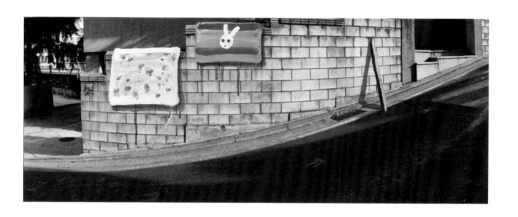

이불 blanket 100×35cm Acrylic on photo 2015

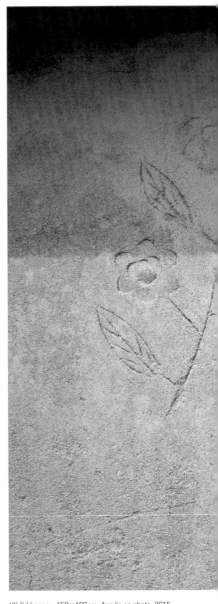

바나나 banana 150×100cm Acrylic on photo 2015

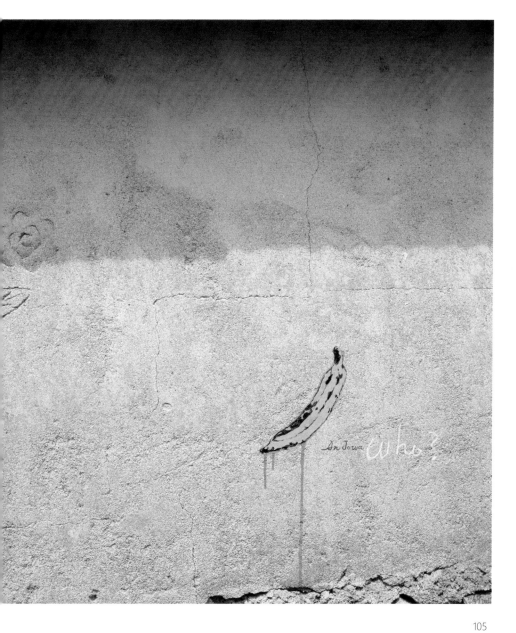

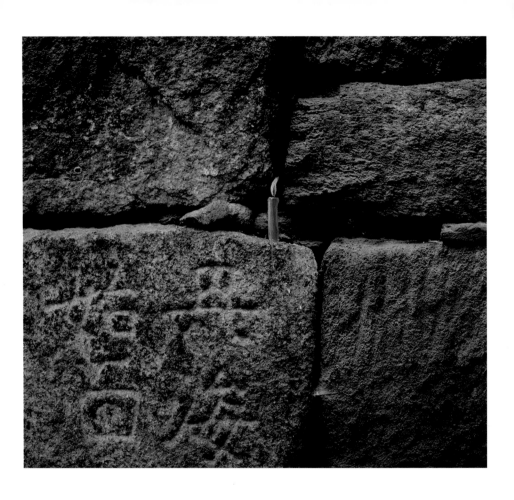

촛불 candle 100×90cm Acrylic on photo 2016

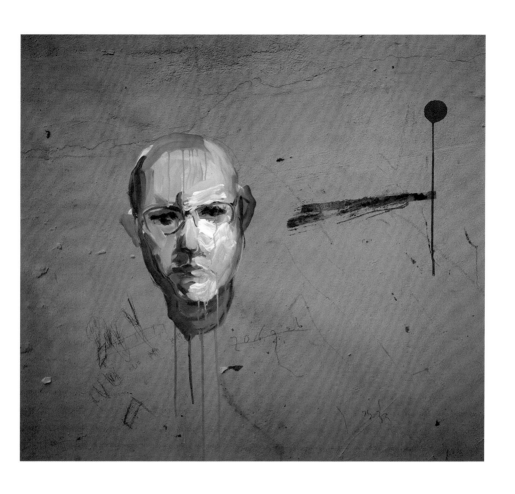

자화상 self portrait 100×90cm Acrylic on photo 2016

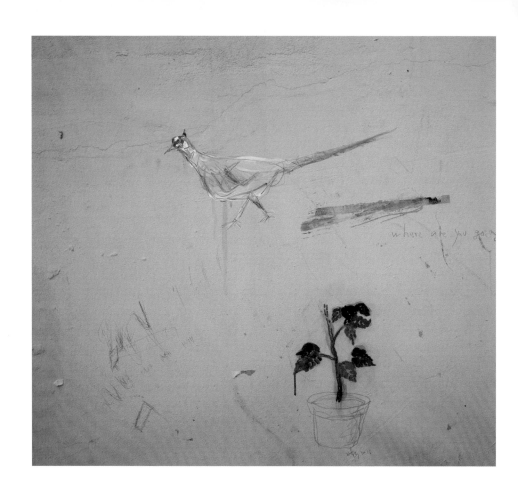

꿩 pheasant 100×90cm Acrylic on photo 2016

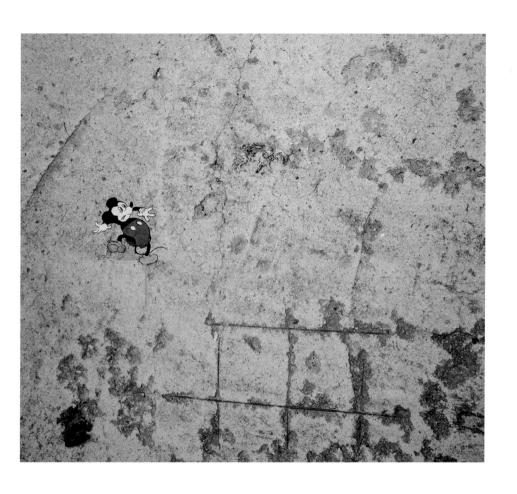

미키 mickey 100×90cm Acrylic on photo 2016

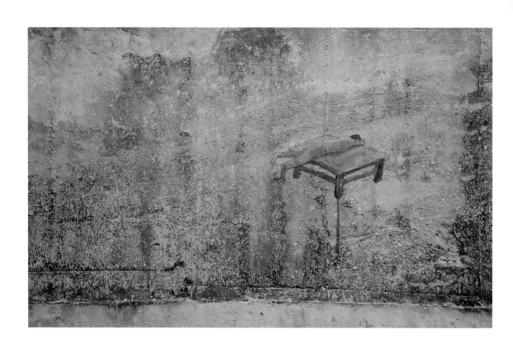

벽 hard wall 100×60cm Acrylic on photo 2016

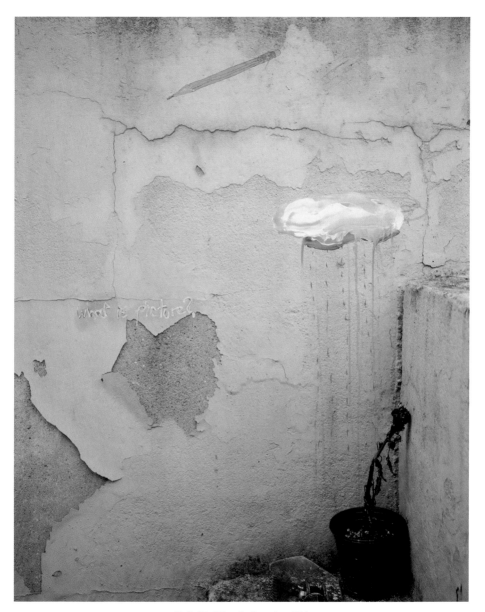

비 rain 80×100cm Acrylic on photo 2016

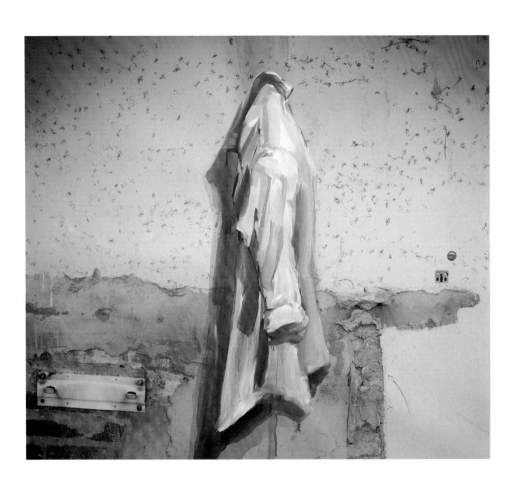

셔츠 shirt 100×90cm Acrylic on photo 2016

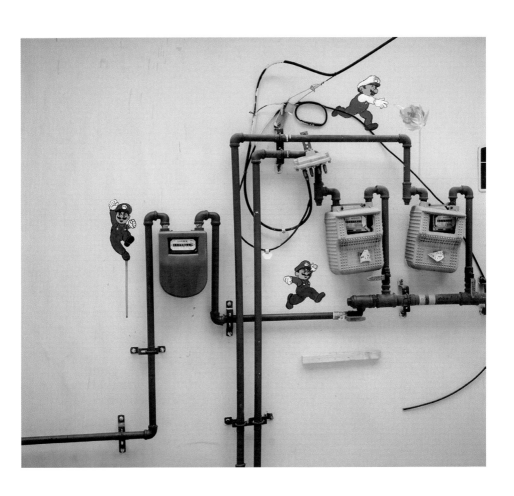

슈퍼 마리오 super mario 100×90cm Acrylic on photo 2016

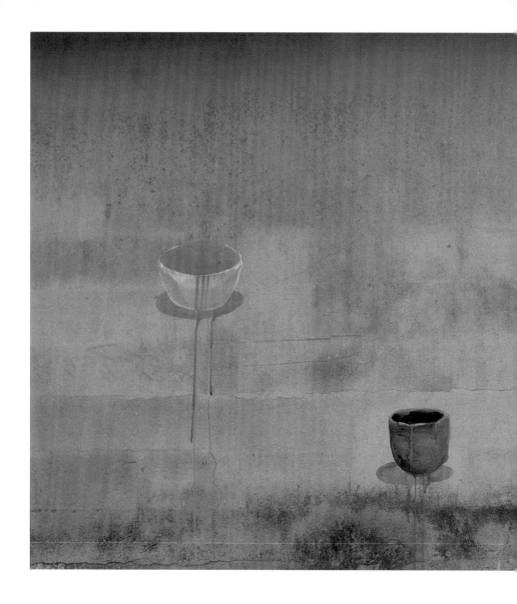

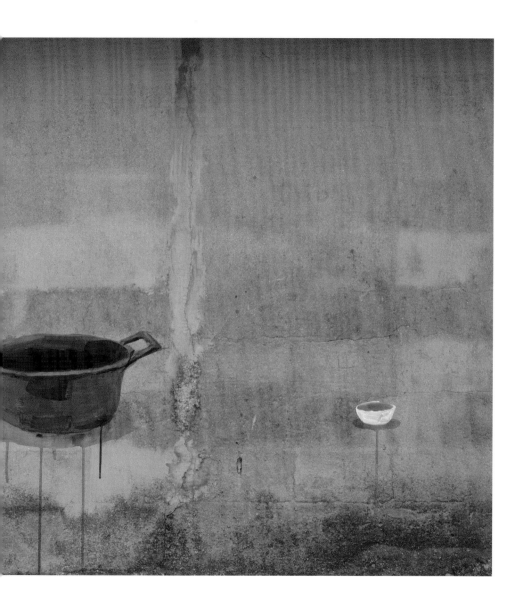

그릇 bowl 200×100cm Acrylic on photo 2015

Underprint
-참새와 짜장면

하던 일을 때려치우고 미술과 사진에 종사한지 삼십년이 넘었다. 알게 된 것은 미술은 지극히 시시한 것이 되었으며 앞으로도 그럴 것이라는 것이다. 이미 이미지를 둘러 싼 주도권은 산업에 넘어 간지 너무 오래이다. 이제 작품들을 사고, 미술관을 짓고, 전시를 기획하고, 팔아먹는 것이 진짜 예술이 되었다. 작가니 뭐니 하는 사람들은 중소 생산자에 지나지 않는다.

언더 프린트 underprint 는 돈이나 우표의 밑바탕에 깔리는 희미한 인쇄를 말한다. 이번 내 작업들도 그와 비슷하다. 여러 곳에서 찍은 벽 혹은 담 사진 위에 뭔가를 그린다는 점에서.

담 사진들은 서울 재개발 지역, 창신동, 한남동에서, 부산, 청주, 전남 신안군에서 찍었다. 어디엔가 쓸 수 있을 것 같아 찍어 놓은 것들이다. 담 위에 왜 뭔가를 그렸냐고? 그냥 그리고 싶어서였다. 십 여 년 전 부터.
우리나라 담은 일본이나 유럽과 전혀 다르다. 한국적이라고 할 수도 있겠다. 엉성함, 정리 덜 됨, 내버려 둠에 가까운 분위기. 그리고 그건 비싼 건물이나 부잣집 담이 아니라야 더 두드러진다.

그릴 내용들을 특별히 정하지도 않았다. 사진을 프린트해서 붙여 놓고 뭔가를 그리고 싶어질 때까지 드로잉을 하거나 생각을 하다 떠오르면 그렸다.
다 그려놓고 보니 몇 그룹으로 나뉜다. 먹을 것과 빈 그릇들, 공사장의 인상과 몽상, 조금은 정치적인 내용이 있는 것들, 이미 잘 알려진 걸작에 관한 언급이나 패러디, 자전적이거나 미술 자체에 대한 냉소로 되어 있다. 또 몇 작품들은 초등학교 일학년인 아들의 도움을 받았다. 아들한테는 같이 그린 작품이 팔리면 십 퍼센트 주기로 했다. 그럴 수 있

기를 바란다.

 여기 까지 쓰고 나서 우연히 김우창의 글을 다시 읽다 그가 한국시의 실패를 말한 대목을 보았다. 서정주를 비롯한 시인들이 일원적 감정주의와 자위적 자기만족의 시를 씀으로서 경험적 집적과 모순을 넘어서는 전체로서의 보편성을 획득하고 구조화 하는데 실패했다고 쓰여 있었다. 구체적 경험과 전체적 보편성이라- 오랜만에 듣는 말이다. 뜨끔했다. 심미적 이성의 리얼리즘이라는 퐁티 영향을 받았다는 이 개념. 사십 여 년 전의 글인데 우리 미술에 적용하면 어떻게 될까? Que sera sera! 될 대로 되겠지. 미술 따위가 어찌 되든 내가 알게 뭔가.

강 홍구

Underprint

-A Sparrow and Jajangmyeon

Over the past thirty years that I've been in the fields of art and photography, art has become exceedingly banal. The authority surrounding images and art has long since handed over to an industry. Nowadays, real art means buying and selling works, building museums and curating exhibitions with the system. Stuck in the midst of all this are the artists of which I consider myself.

An "underprint" refers to the subtle print found on paper currency or stamps. My works are kind of similar in a way that they are drawings onto pictures of walls from different places: Seoul's redevelopment areas, Changsin-dong, Hannam-dong, Busan, Cheongju, and Sinan-gun of Jeollanam-do. I took these photos at the time thinking I could make use of them somewhere. I then made drawings on them - something I've wanted to do for at least ten years.

Walls in Korea are uniquely Korean - flimsy, unorganized, left alone. These qualities are noticeable only in walls that are not of expensive buildings or houses of the rich.

I did not particularly make decisions on what to draw before making the works. I simply printed out the pictures and then made drawings until I wanted to make a specific one or until ideas occurred in my mind.

Works can be grouped into a few different categories: food; empty bowls;

impressions and fancies of construction sites; slight political messages; references to and parodies of masterpieces; autobiographical content, and an overall cynicism on art. To my eight-year-old son, who contributed to some of the works, I promised to give a commission of 10 percent if they're sold.

While writing this, I came across Woochang Kim's writing on the failure of Korean poetry. He mentions that poets, including Jeongju Seo, wrote poems that were too sentimental and personal in nature. The poems of such self contented nature were devoid of any effects on the common cultural world that could respond or relate to concrete experiences and greater universality.

Concrete themes, experiences and general universality - I have not heard of those words for a long time. Where is the art that embodies this? This ideology based on aesthetic reasoning, influenced by Merleau-Ponty, startled me. It emerged over forty years ago, but what would happen if such reasoning is applied to the art of today? Que sera sera! I guess things will turn out one-way or the other.

Kang, Hong-Goo

녹색연구
Study of Green

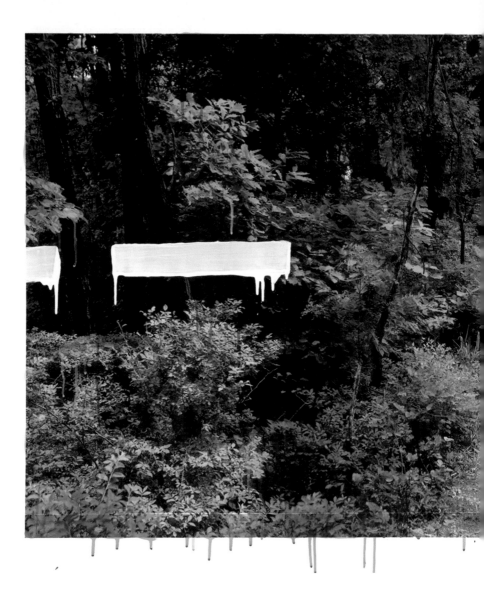

study of green-path 193×106cm Acrylic on pigment print 2012

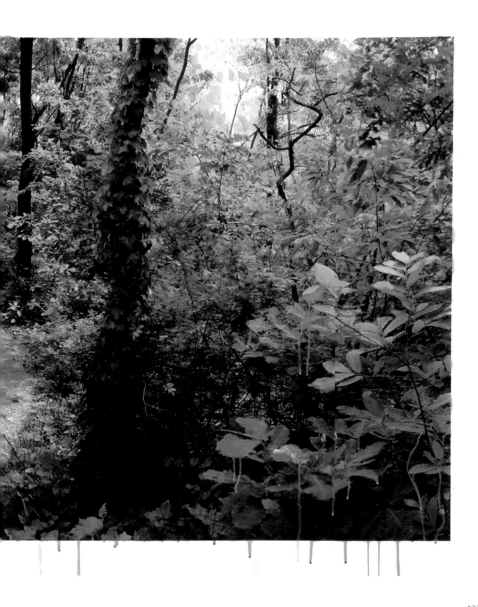

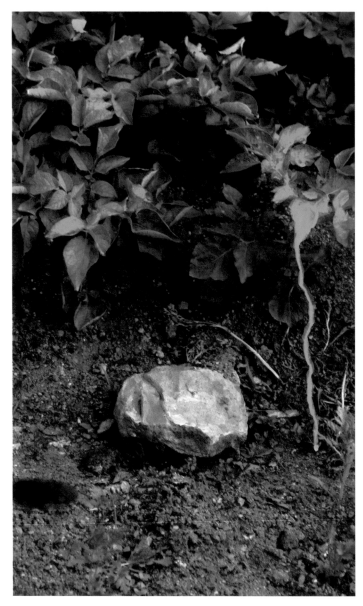

study of green-stone 35×53cm Acrylic on pigment print 2012

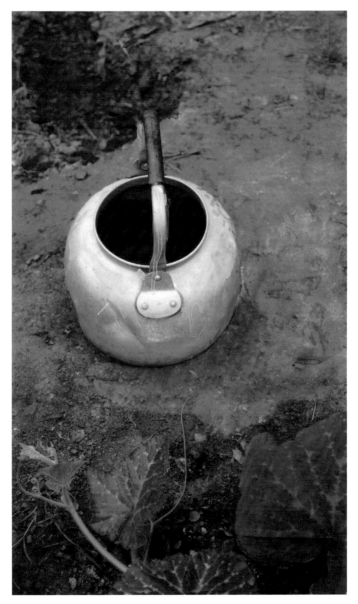

study of green-kettle 35×53cm Acrylic on pigment print 2012

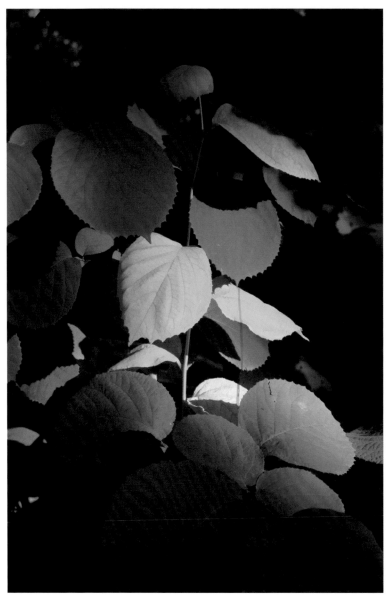

study of green−wide leaf 90×134cm Acrylic on pigment print 2012

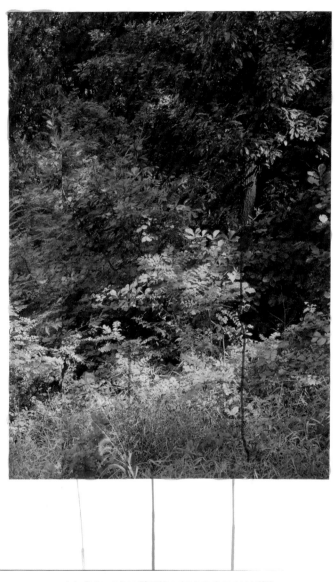

study of green-red tree 70×111cm Acrylic on pigment print 2012

study of green-small field 81×109cm Acrylic on pigment print 2012

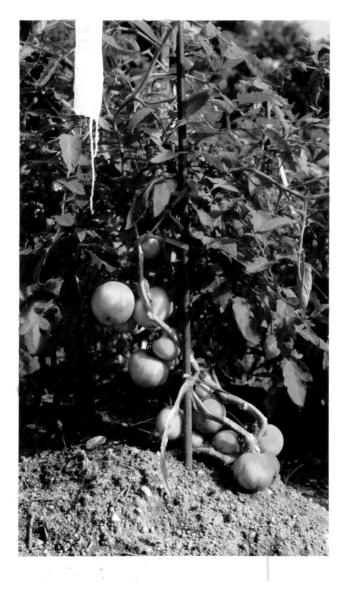

study of green-tomato 60×100cm Acrylic on pigment print 2012

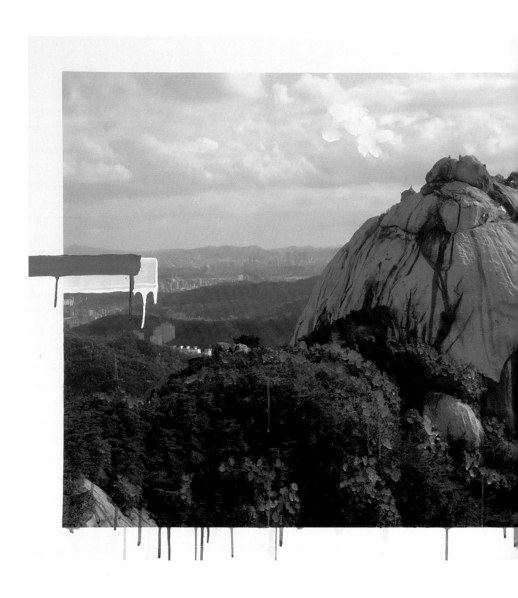

study of green-eagle peak 213×106cm Acrylic on pigment print 2012

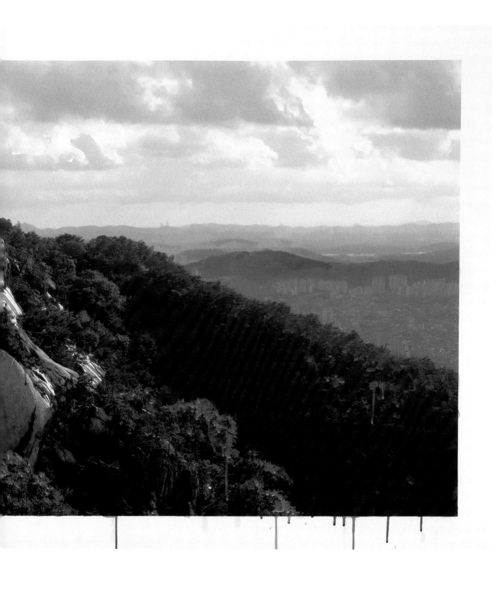

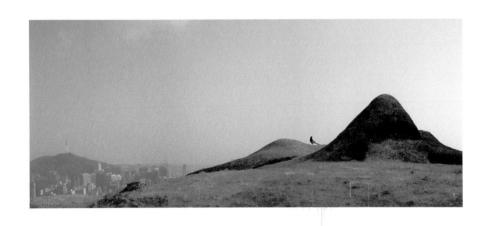

study of green-namsan 196×101cm Acrylic on pigment print 2012

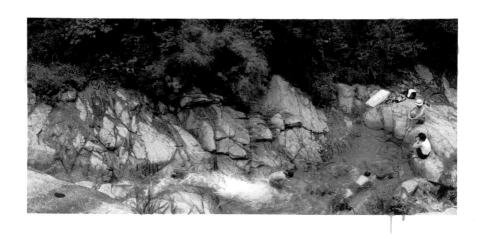

study of green-stream 110×55cm Acrylic on pigment print 2012

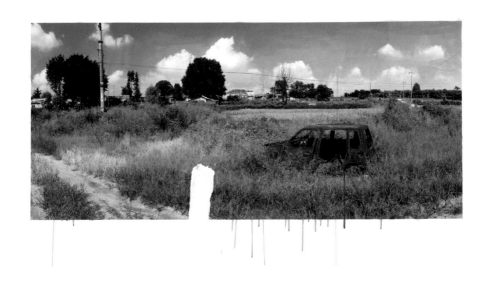

study of green−rusty car 173×96cm Acrylic on pigment print 2012

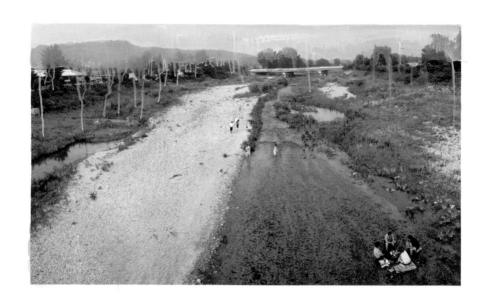

study of green-summer 110×70cm Acrylic on pigment print 2012

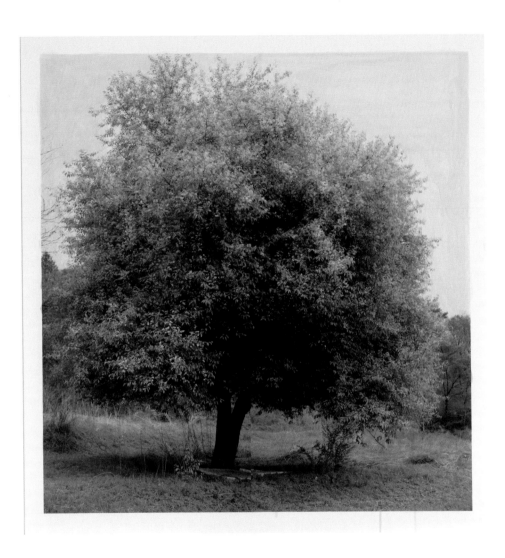

study of green-spring 112×117cm Acrylic on pigment print 2012

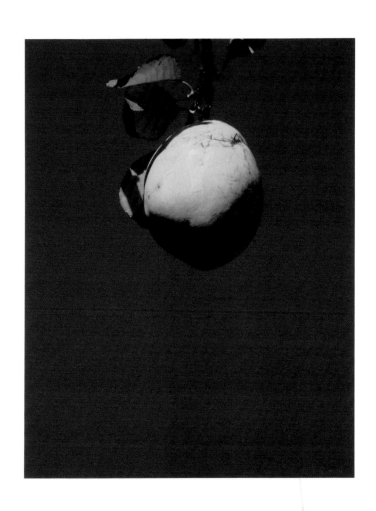

study of green-chinese quince 82×107cm Acrylic on pigment print 2012

study of green-horses 60×40cm Acrylic on pigment print 2012

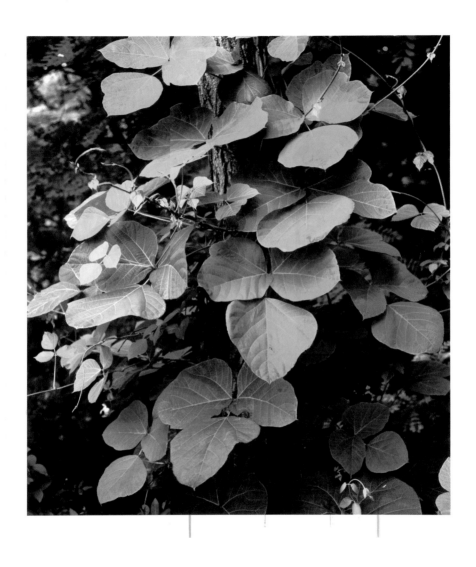

study of green-arrowroot 90×134cm Acrylic on pigment print 2012

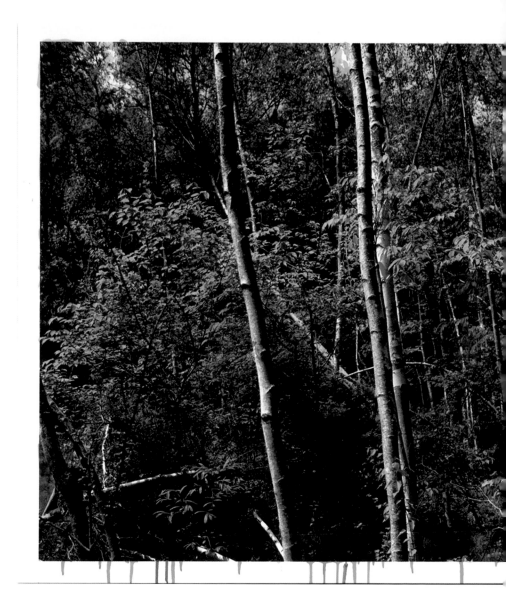

study of green-white birch B 200×100cm Acrylic on pigment print 2012

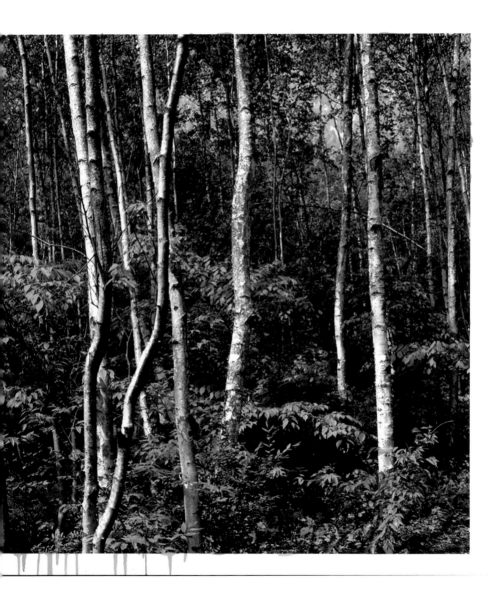

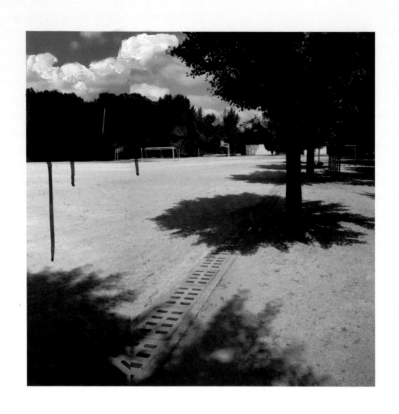

study of green-white cloud 56×76cm Acrylic on pigment print 2012

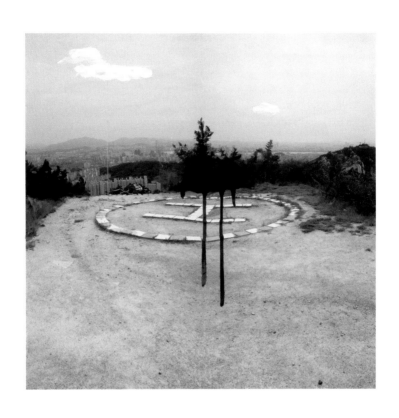

study of green-heli port 56×76cm Acrylic on pigment print 2012

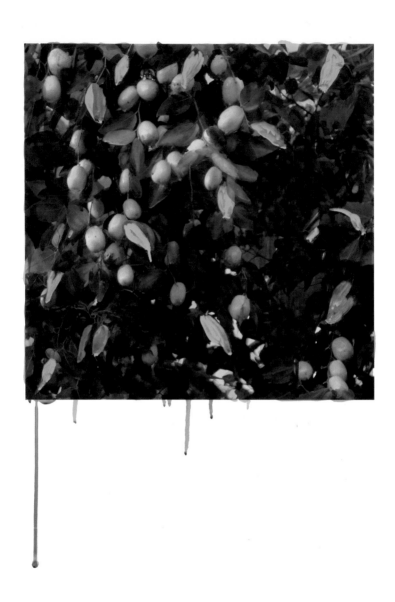

study of green-jujube 56×76cm Acrylic on pigment print 2012

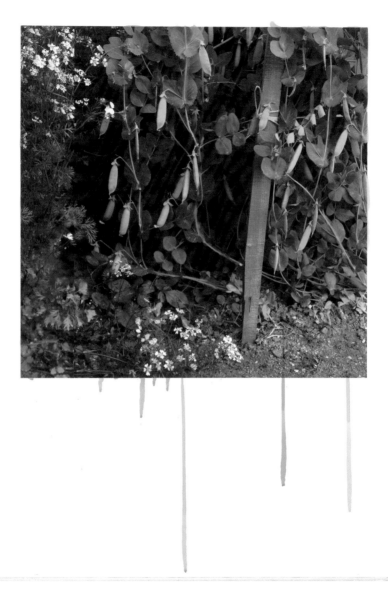

study of green-pea 56×76cm Acrylic on pigment print 2012

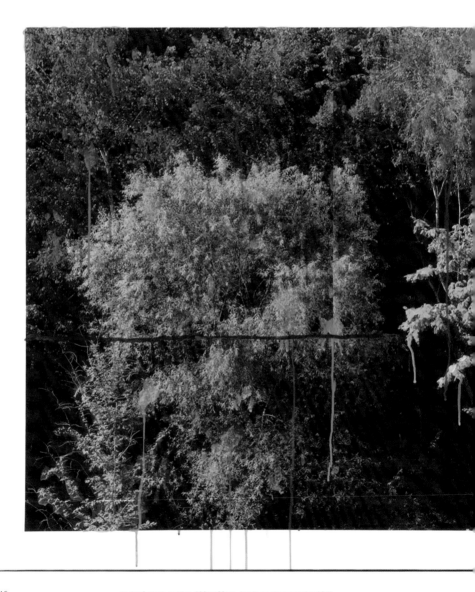

study of green−red line 200×100cm Acrylic on pigment print 2012

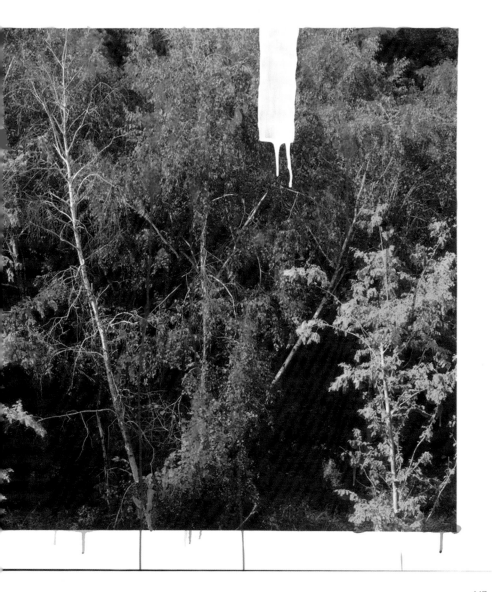

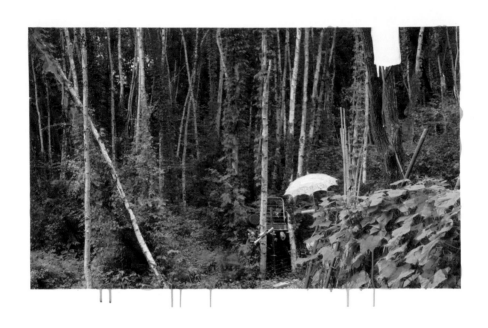

study of green–yellow parasol 110×70cm Acrylic on pigment print 2012

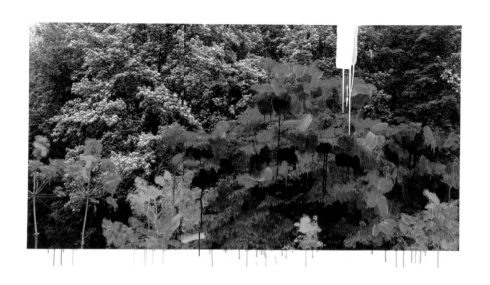

study of green-white flower 200×90cm Acrylic on pigment print 2012

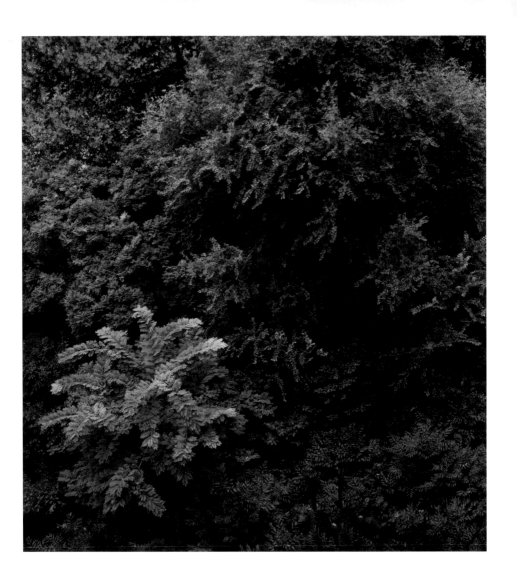

study of green-grove 112×120cm Acrylic on pigment print 2012

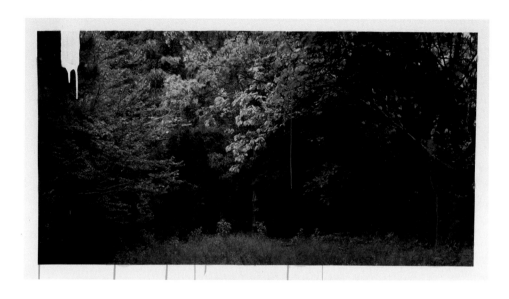

study of green-garden 135×67cm Acrylic on pigment print 2012

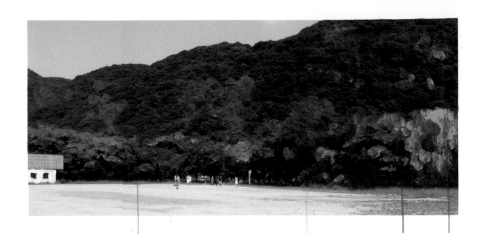

study of green-game 110×55cm Acrylic on pigment print 2012

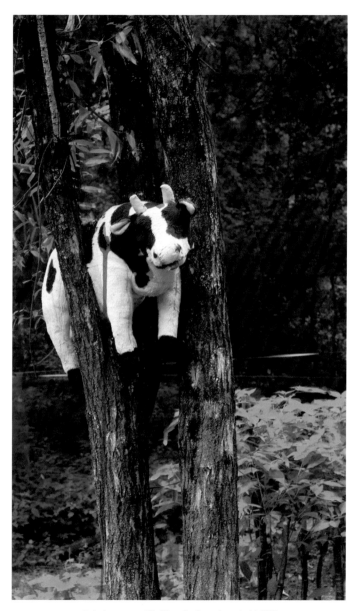

study of green-cow 35×53cm Acrylic on pigment print 2012

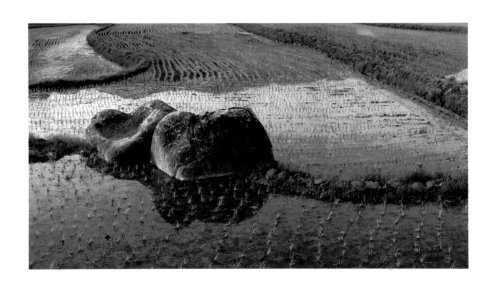

study of green-rice field 161×91cm Acrylic on pigment print 2012

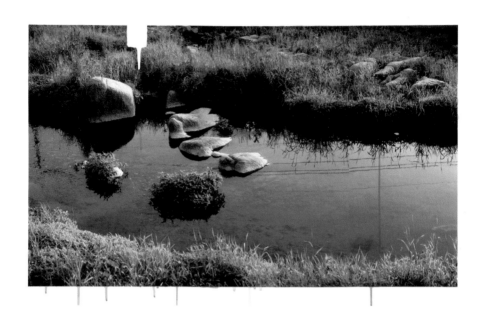

study of green-water　110×70cm　Acrylic on pigment print　2012

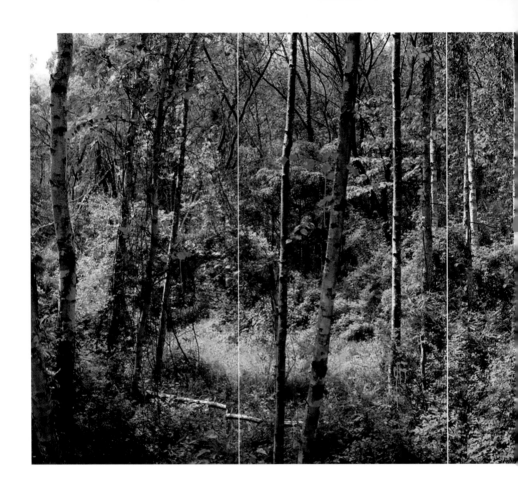

study of green-white birch A 480×190cm Acrylic on pigment print 2012

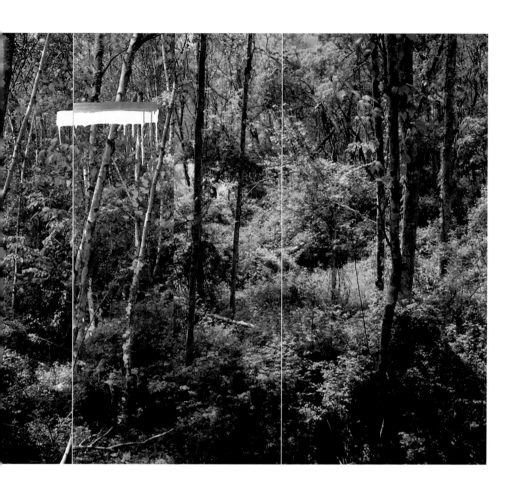

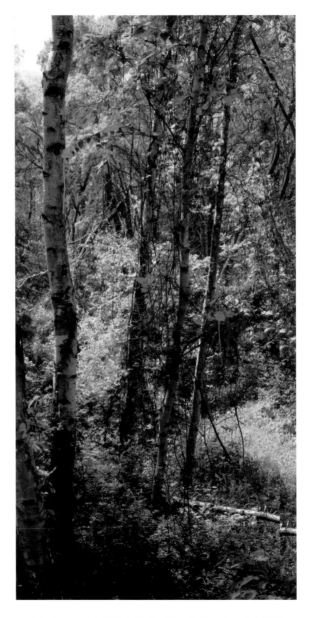

study of green part of white birch A 1 90×190cm Acrylic on pigment print 2012

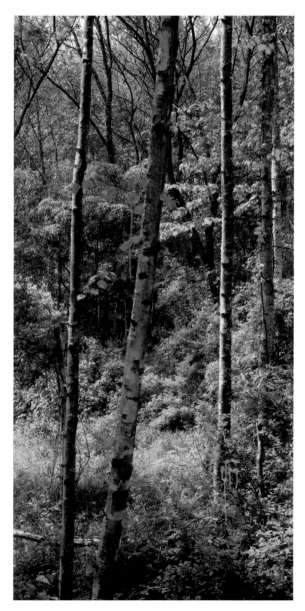

study of green part of white birch A 2 90×190cm Acrylic on pigment print 2012

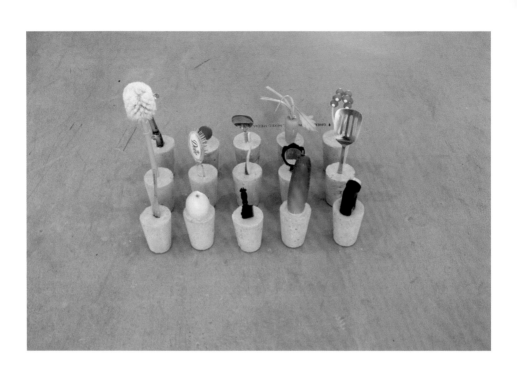

study of green-green growth Flexible Size Installation mixied media 2012

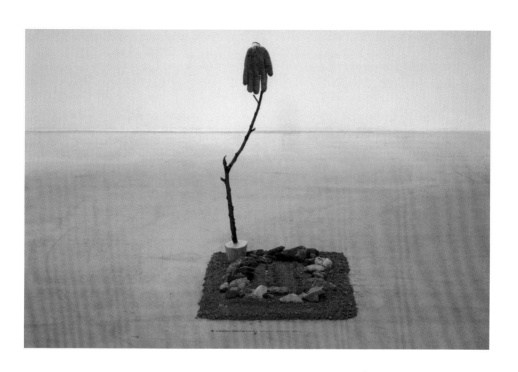

study of green-glove Flexible Size Installation mixied media 2012

녹색 연구
-支離滅裂

　녹색에 관한 작업을 해야겠다고 마음먹은 것은 6년 전 쯤이다. 봄이 되면 뭉게구름처럼 피어오르는 야산 나무들의 새잎에 반하게 되면서 부터이다. 누군가는 그 이유가 나이가 들었기 때문이라고도 했다. 그럴 것이다. 그 놀랍고 다양한 녹색들을 카메라를 들고 찍으면서 사진으로 다 담을 수 없는 뭔가가 있다는 생각을 했다. 그래서 그냥 사진이 아니라 사진 위에 채색하는 시도를 2007년에 처음 했다. 몇 점 만들어본 다음에 같은 방법을 이용해 2010년 〈그 집〉전시를 했다.

　이번 전시 준비를 하면서도 생각은 단순했다. 사 월말 오월 초의 나무들이 보여주는 엄청나게 다양한 녹색들을 어떤 식으로든지 표현해보는 것이었다. 그러나 작업이 진행 되면서 생각은 점점 복잡해지기 시작했다. 깊어지거나 새로워지는 것이 아니라 그냥 복잡해졌다. 예를 들면 인간은 어떻게 식물들을 그려왔나? 그 배경은 무엇인가? 따위부터 아주 오래된 개인적인 녹색에 대한 기억까지. 그뿐 아니라 녹색 성장, 녹색 인증 따위의 이념적 상투어들과 어렸을 때 식물을 가지고 놀던 기억까지 뒤섞이면서 드디어 지리멸렬해졌다.

　지리멸렬은 그래서 이 전시의 열쇠말이 되었다. 생각해보니 지리멸렬은 우리시대의 열쇠말이기도 하다. 그 잘났다는 이념도, 종교도 다른 어떤 무엇도 이 재난과도 같은 인간의 삶을 구원하지 못했다. 그런데 인간은 이런 삶을 끝장낼 방법도 오래전부터 알고 있었다. 욕망을 줄이는 것. 그러나 실천은 되지 않는다. 오히려 욕망은 시스템화 되어 사회적 현상을 넘어 후천성 생물학적 DNA로 변화되고 있다는 느낌이 든다. 아마도 인간은 그렇게 살도록 프로그램된 것이나 아닐까 하는 생각이 들 지경이다. 섣부른 생물학적 운명론이 되는 것 같아 그렇기는 하지만.

우리 시대의 진정한 예언서인 탐정, 범죄 소설과 SF소설들은 직접, 혹은 비유적으로 인간에 관해 말한다. 예를 들면 〈알프레드 엘튼 반 보그트〉가 쓴 〈우주선 비이글호〉에 나오는 우주 생물들을 역사적 단계로 구분하는 방법의 경우가 흥미롭다.

우주선에 탑승한 한 역사학자는 초기농민기적 특성을 가진 우주 생물들은 종족보존을 본능적으로 우선시하기 때문에 위기의 상황에서도 그렇게 행동하리라는 추론을 한다. 그리고 그걸 바탕으로 우주선을 위기에서 구한다. 토인비의 역사구분 방식의 영향을 받았다는데 이런 관점을 인간에게 적용하면 어떨까? 인간의 문명은 어떤 단계에 해당될까? 초기농민기를 넘어섰을까? 이토록 지리멸렬하고 분열적이며 어리석은 삶을 유지하는 것을 보면 혹시 자기파괴적 단계에 이른 것은 아닐까?

어쨌든 녹색연구는 작업실을 출발해 북한산에 오르는 산책 길에 대한 일종의 기록이다. 그 과정에서 농업본능을 버리지 못하는 도시인들의 작은 채소 밭, 논, 농작물에서 나무와 숲을 지나 산꼭대기에서 도시를 바라보는 것이 뼈대를 이룬다. 그러나 그것들로 다 말하지 못하는 녹색에 대한 기억과 여러 생각 등은 드로잉과 설치를 이용했다. 물론 전시 자체는 잘 조직 된 것은 아니다. 그럴 생각도 별로 없었다.

여기까지 쓰고 보니 이 글도 역시 지리멸렬하다. 하지만 글과 전시가 지리멸렬한 것은 당연한 일이기도 하다. 지리멸렬한 세계에서 지리멸렬한 전시란 필연적이지 않은가?

강 홍구

Study of Green

: Incoherence

It was about six years ago that I decided to do a study of green. I had fallen in love with the new leaves growing like fluffy clouds on hillside trees in spring. Someone said that it was because I was growing old. That may be so. As I took photos of the amazing variety of green colors, I thought that there was something I couldn't quite capture using my camera. That is why I didn't just leave the photos as they were but tried to paint over them for the first time in 2007. After trying out a few pieces, I used the same method to hold my exhibition "The House" in 2010.

My idea was also simple as I prepared this exhibition. It was to use any means possible to try and express the astonishingly diverse green colors of the trees in late April and early May. But, as my work progressed, my idea became more and more complicated. They didn't gain any depth or spark new ones but simply became complicated. For example, I would ask questions such as "How have humans been painting plants? And what was the background?" and even think of very old personal memories about green. Not only that, ideological platitudes such as green growth and green certification mixed with memories of my childhood playing with plants to end up as something incoherent.

This is why incoherence became the keyword for this exhibition. Come to think of it, incoherence is also the keyword for our age. Nothing, not even so-called great ideologies and religions, has saved this disaster of a human life. But men have known for a long time how to end such a life: reducing desire. But if can't be put into practice. On the contrary, it feels that desire is becoming systematic, becoming more than a sociological phenomenon and becoming an acquired biological DNA. It almost seems like humans are programmed to live that way, at the risk of turning this into a rash biological fatalism.

 Detective novels, crime novels, and sci-fi novels, which are our epoch's true prophetic writings, directly or metaphorically speak of humans. For example, it is interesting to note the way alien organisms are categorized by different stages in history in "The Voyage of the Space Beagle" by Alfred Elton van Vogt.

 A historian aboard the spaceship infers that, since alien organisms that have the characteristics of early agricultural times instinctively put the preservation of the species above all else, they would do so even in critical situations. And he uses this inference to save the spaceship from an emergency. Apparently, it was influenced by the Tonybee's Study of History.

What if we applied this point of view to humans? At which stage would our civilization be? Would we be past the early agricultural stage? Or maybe the fact that we are living such incoherent, schizophrenic and foolish lives means that we have reached the self destruction stage?

In any case, study of green is a type of record that follows the walkway from the workroom up Mt.Bukhan. The main body consists of moving through small vegetable patches made by city people unable to let go of their farming instincts, rice paddies and crops to passing trees and forests to view the city thoughts of green that were still not fully expressed. Of course, this exhibition itself isn't well organized. That was never really the intention anyway.

After reading what I have written so far, even this writing seems incoherent. But it is also a given that the writing and exhibition are incoherent. Isn't it inevitable that an incoherent exhibition is born in an incoherent world?

Kang, Hong-Goo

서울산경
Seoul Mountain Scenery

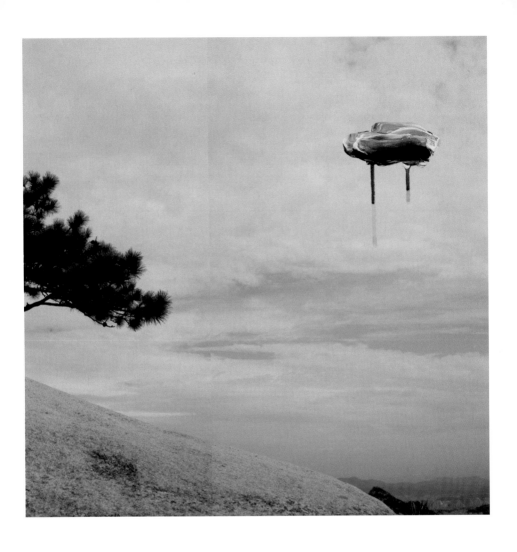

구름 cloud 1 50×50cm Photo & mixed media 2013

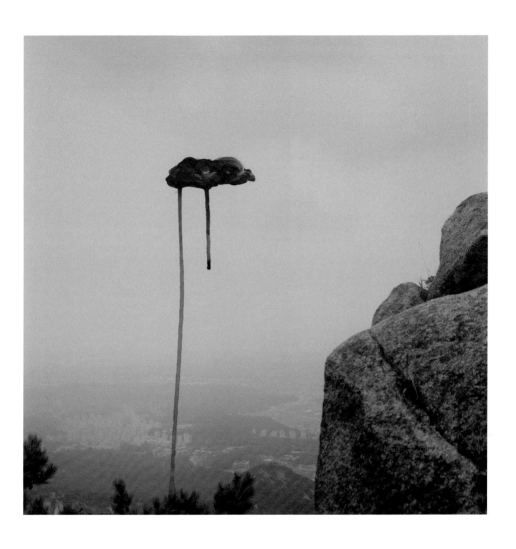

구름 cloud 3 50×50cm Photo & mixed media 2013

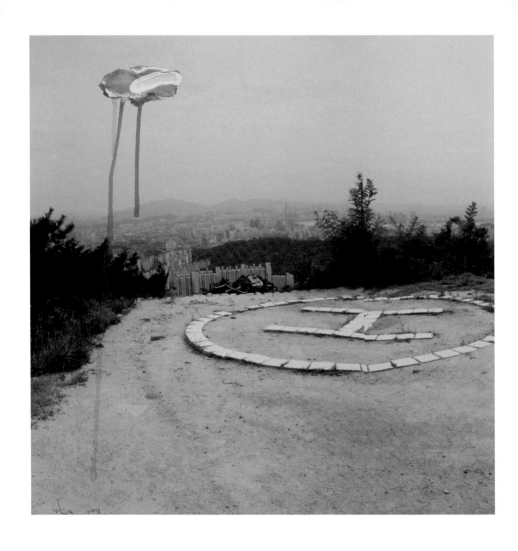

구름 cloud 2 50×50cm Photo & mixed media 2013

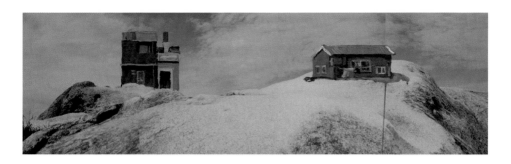

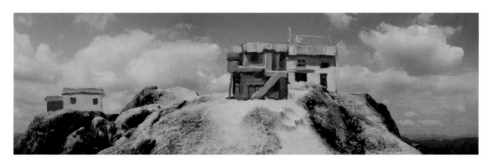

집 house 5 105×32cm Photo & mixed media 2013
집 house 4 105×32cm Photo & mixed media 2013

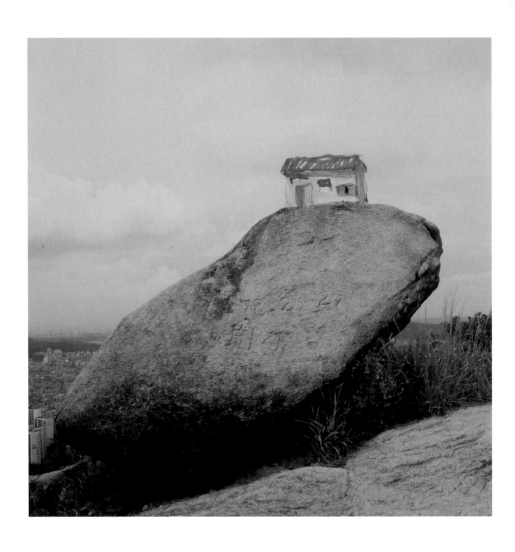

집 house 2 50×50cm Photo & mixed media 2013

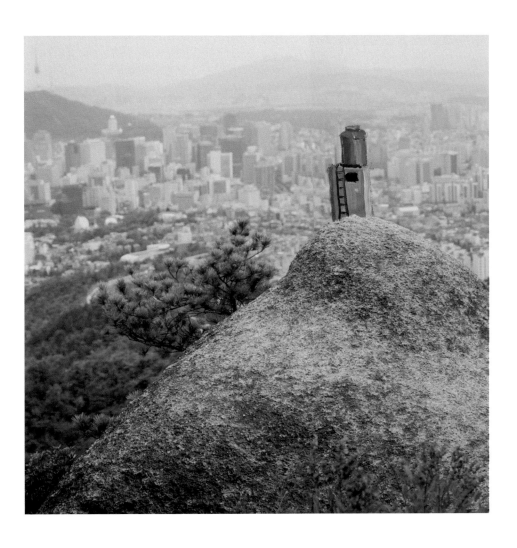

집 house 3 50×50cm Photo & mixed media 2013

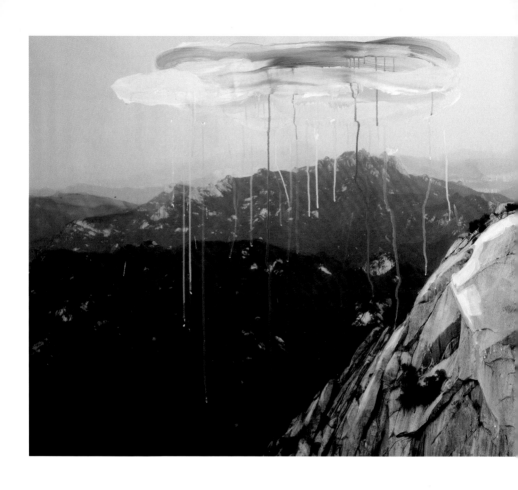

인수봉 Insoobong 200×80cm Photo & mixed media 2013

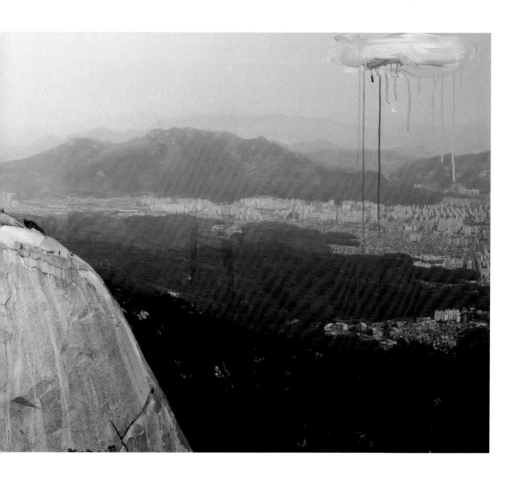

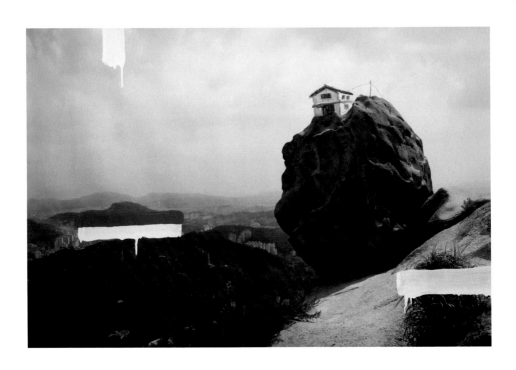

족두리봉 Jokdoori bong 150×100cm Photo & mixed media 2013

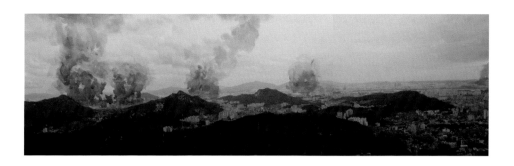

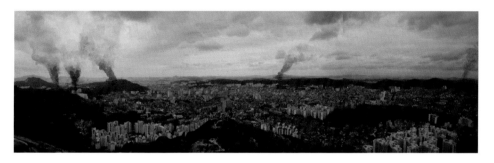

연기| smoke 1 105×32cm Photo & mixed media 2013
연기| smoke 2 105×32cm Photo & mixed media 2013

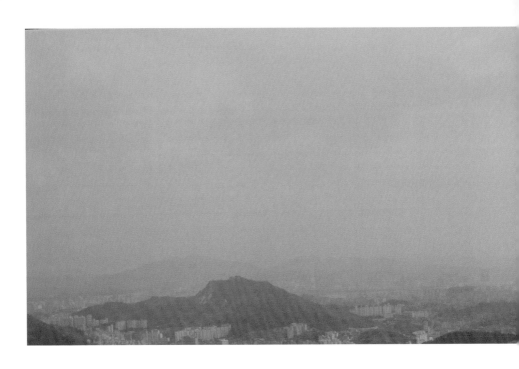

집 house 6 100×30cm Photo & mixed media 2013

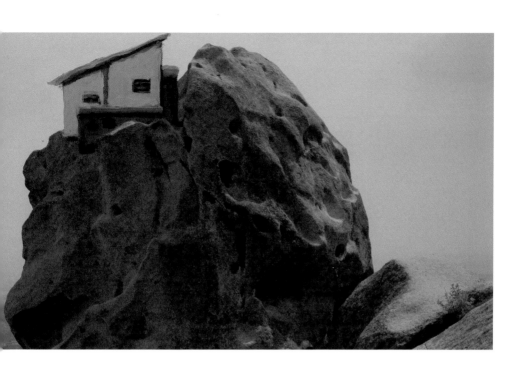

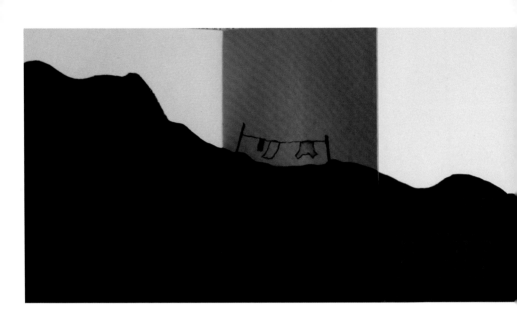

Profile

강홍구 Kang, Hong-Goo 姜洪求

1956 출생
1976 목포교육대학 졸업
1987 홍익대학교 미술대학 회화과 졸업
1990 홍익대학교 대학원 서양화과 졸업

개인전
2017 안개와 서리-10년 (원앤 제이 갤러리, 서울)
2016 청주 - 일곱 마을의 도시 (우민아트센터, 청주)
 청주 - 일곱 마을의 도시 (스페이스22, 서울)
 under print - 참새와 짜장면
 (서학동 사진관, 전주)
2015 under print - 참새와 짜장면
 (원앤제이 갤러리, 서울)
2013 서울 산경 (테이크아웃 드로잉, 서울)
2013 사람의 집 - 프로세믹스 부산
 (고은사진미술관, 부산 · 우민아트센터, 청주
 · 원앤제이 갤러리 · 트렁크 갤러리, 서울)
2012 녹색연구 (원앤제이 갤러리, 서울)
2011 서늘한 집 (고은사진미술관, 부산)
2010 그 집 (원앤제이 갤러리, 서울)
2009 사라지다 - 은평 뉴타운에 대한 어떤 기록
 (몽인아트센터, 서울)
2006 풍경과 놀다 (리움미술관 로댕갤러리, 서울)
 어의도 가는 길 (space kandada, 도쿄)
2004 오쇠리 풍경 (갤러리 숲, 서울)
2003 드라마 세트 (대안공간 풀, 서울)
2002 한강시민 공원 (요스카 뷰잉룸, 도쿄)
1999 위치, 속물, 가짜
 (금호미술관, 서울 · 갤러리 그림시, 수원)

1992 갤러리 사각 (서울)

2인전
2015 강홍구, 박진영 사진전 - 우리가 알던 도시
 (국립현대미술관, 과천)
 최진욱, 강홍구 이인전 - 탈주의 방법
 (갤러리 룩스, 서울)
2009 강홍구, 노순택- 늙은 개와 구르는 돌
 (갤러리 킹, 서울)

단체전
2016 아주 공적인, 아주 사적인
 (국립현대미술관 서울관, 서울)
 리서치, 리서치 (우정국 아트센터, 서울)
 끝은 시작이다 (원앤제이 신당동, 서울)
 동백꽃 뮐퓌유 (아르코 미술관, 서울)
 X 1990년대 한국미술 (서울시립미술관, 서울)
2015 루나포토 페스티벌 (갤러리 류가헌, 서울)
2014 사회적 풍경 Parallax view
 (LIG 아트스페이스, 서울)
 한강의 어제와 오늘 (세빛 섬, 서울)
 강북의 달 (북서울시립미술관, 서울)
 콜라주 아트 (경기도미술관, 안산)
2013 다시 쓰기 (두산갤러리, 서울)
 현대적 관광 (일현미술관, 양양)
 근대성의 새 발견 (문화서울역 284, 서울)
 아티스트 포트폴리오 (사비나미술관, 서울)
 그날의 홀라 송 (고은사진미술관, 부산)

사진과 도시 (경남도립미술관, 창원)
2012 이것이 대중미술이다 (세종문화회관, 서울)
히든 트랙 (서울시립미술관, 서울)
화이트 서머 (신세계갤러리, 서울)
진도 소리, 삶을 그리다
(광주 신세계갤러리, 광주)
(불)가능한 풍경 (리움미술관 플라토, 서울)
천개의 마을, 천개의 기억
(서울시립미술관, 서울)
메타데이터:전복적 사진 (우민아트센터, 청주)
한국 현대미술 - 시간의 풍경들
(성남아트센터, 성남)
진단적 정신, 카트스트로피
(동대문 디자인 플라자, 서울)
2011 서울, 도시 탐험 (서울시립미술관, 서울)
오늘과 옛날-나의 살던 고향은
(부평아트센터, 인천)
부산, 익숙한 공간- 낯선 도시
(신세계 갤러리, 부산)
광화문 네거리에서 길을 잃다
(문화공간 예무, 서울)
삶과 풍토 (대구시립미술관, 대구)
2010 범죄 사회 (대안공간 루프, 서울)
장소의 기억, 기억의 재현 (공간갤러리, 서울)
긍지의 날 (대안공간 풀, 서울)
나의 살던 동네 (부평아트센터, 인천)
원 앤 제이 갤러리, Pierre koenic
(Pierre koenic, L,A.)
A positive view (서머셋하우스,런던)

2009 모호한 증, 애매한 겹 (갤러리 룩스, 서울)
드림 하우스 (대안공간 풀, 서울)
메이드 인 코리아 (하노버, 독일)
늙은 개와 구르는 돌 (갤러리 킹, 서울)
신호탄 (국립현대미술관, 서울)
더 마크 (갤러리 마크, 서울)
2008 Wake up (갤러리 나우, 서울)
Trace (원앤제이 갤러리, 서울)
한국현대사진 60년 1948-2008
(국립현대미술관, 과천)
Bside (두 아트 서울 갤러리, 서울)
동강사진예술상 수상자전
(동강사진박물관, 영월)
파편의 선택 The options of fragment
(경원대학교 K-art space, 성남)
The Points of the Compass 나침반의 끝
(Mexico City, MEXICO Habana, CUBA)
팝 앤 팝 POP N POP (성남아트센터, 성남)
2007 아시아 아트 나우
(쌈지갤러리, 서울 · 아라리오 북경, 베이징)
적절한 풍경 (스페이스 바바, 서울)
개관 기념전-사회 (트렁크갤러리, 서울)
종촌 가슴에 품다-종촌리 프로젝트 (종촌리)
이상한 나침반 (갤러리 눈, 서울)
환영의 거인 (세종문화회관, 서울)
시티 넷 아시아 (서울시립미술관, 서울)
현대 작가 10인전 (한미사진미술관, 서울)
달콤 살벌한 대선 (충정각, 서울)
도시 읽기 (토포하우스, 민사협)

2006 방아쇠를 당겨라
 (갤러리 비비 스페이스, 대전)
 時間의 얼굴, 얼굴의 時間
 (아트 스페이스 흄, 서울)
 사진의 꿈 (동강사진축제, 영월)
 서울 국제 사진 페스티벌 (토포하우스, 서울)
 서울 프린지 페스티벌 (대안공간 쌈지, 서울)
 아시아 지금 (쌈지 스페이스, 서울)
 외 다수

작품소장

부산시립미술관 (부산)
아트선재센터 (서울)
뚜르미술관 (프랑스)
국립현대미술관 (과천)
부산민주화공원 (부산)
문예진흥위원회 (서울)
5.18기념재단 (광주)
한미사진미술관 (서울)
경기도미술관 (안산)
삼성리움미술관 (서울)
서울시립미술관 (서울)
몽인아트센터 (서울)
고은사진미술관 (부산)
우민아트센터 (청주)

지은 책

2017 강홍구-한국현대미술선 (헥사곤)
2016 청주-일곱 마을의 도시 (우민아트센터, 청주)
2015 우리가 알던 도시 (국립 현대 미술관, 과천)
2013 사람의 집-프로세믹스 부산 (고은사진미술관)
2010 작품집, 강홍구 1996-2010 (원앤제이)
2006 디카를 들고 어슬렁 (마로니에 북스)
2002 그림 속으로 난 길 외 (아트북스)
2001 시시한 것들의 아름다움 (황금가지)
1995 앤디 워홀 : 거울을 가진 마술사의 신화
 (도서출판 재원)
1994 미술관 밖에서 만나는 미술 이야기1.2
 (내일을 여는 책)

수상

2015 루나 포토 페스티벌 올해의 작가
2008 동강 사진예술상 (동강 사진예술 위원회)
2006 올해의 예술가상 시각예술부문 (문예진흥위원회)

kaho99@daum.net

Kang, Hong-Goo 강홍구

Born in 1956

Education
1976 Mok-po Teachers Collage
1988 Hong-ik University Art College(B.F.A)
1990 Hong-ik University Art Graduate School(M.F.A)

Solo Exhibition
2017 Mist and frost-10years
 (One & J Gallery, Seoul)
2016 Cheongju - City of Seven Villages
 (Wumin Art center, ChungJoo)
 Cheongju - City of Seven Villages
 (Space22, Seoul)
 Under print - sparrow and jajangmyeon
 (seohakdong photo,Junju)
2015 Under print - sparrow and jajangmyeon
 (One & J Gallery, Seoul)
2013 Mountain in Seoul
 (Take out drawing, Seoul)
2013 House of Human being- Proxemics Busan
 (Goeun Photo Art Museum, Busan)
2012 Study of Green (One & J Gallery, Seoul)
2011 House
 (Goeun Photo Art Museum, Busan)
2010 The House (One & J Gallery, Seoul)
2009 Vanishi away- a record of
 Eunpyoung new town
 (Mongin Art Center, Seooul)
2006 (Leeum Museum, Rodin Gallery, Seoul)
 (Kandada, Tokyo, Japan)
2004 (Gallery Soop, Seoul)
2003 (Alternative Space Pool, Seoul)
2002 (Yoska viewing room, Tokyo, Japan)
1999 Kumho Museum of Ar

(Seoul. Gallery Grimsi, Soowon)
1992 (Sagak Galley, Seoul)

Duo Exhibition
2015 City We Have Know-Photographs by
 Kang Hong Goo & Area Park
 (National Museum of Contemporary Art,
 Gwachun)
 Manner of Escape - Kang Hong-Goo,
 Choi Jin Wook (Gallery Lux, Seoul)
2009 Old dog and Rolling stone-
 Kang Hong-Goo, No Soon Tak
 (Gallery King, Seoul)

Selective Group Exhibition
2015 Luna Photo Festival (Ryugahun, Seoul)
2014 Parallax view (LIG Art Space, Seoul)
 Yesterday and Today of HanGang
 (Sevit Sum, Seoul)
 Moon of Gangbook
 (North Seoul municipal Museum, Seoul)
 Collage Art (Kyunggi Museum, Ansan)
2013 Dictate (Doosan Art center, Seoul)
 Modern Tourism
 (llhyun Museum, Yangyang)
 New revelation of Modernism
 (Seoul Culture Station 284, Seoul)
 Artist Portfolio (Savina Museum, Seoul)
 Hula song of the day
 (Goeun Photo Art Museum, Busan)
 Photo and City
 (KyungNam Museum, Changwon)
2012 This is Popula Art (Sejong Art Hall, Seoul)
 Hidden track
 (Seoul Municipal Museum, Seoul)

White summer (Shinsegae Gallery, Seoul)
Jindo sori, Life drawing
(Shinsegae Gallery, Kwang ju)
(Im)possible Landscape
(Leeum Museum, Plateau)
Thousand village, Thousand memory
(Seoul Municipal Museum)
Meta Dater: Subverisve Photography
(Wumin Art center, ChungJoo)
Korea contemporay Art-Landscapes
of Time (SungNam Art center, SungNam)
Diagnostic Mind, Catastrophe
(Dongdaemoon Design Palza, Seoul)
2011 Seoul, city Exploration
(Seoul Municipal Museum, Seoul)
Now and Yesterday- My Home town
(Boopyung Art center, Inchon)
Busan, Familar spce-strange city
(Shinsegye Gallery, Busan)
Lost at the Kawanghwamoon
(culture space Yemu, Seoul)
Life and Climate
(Daegu Municipal Museum, Daegu)
2010 Society of Crime (Loop, Seoul)
Memory of site, Represantation of memory
(Space Gallery, Seoul)
The day of pride
(Alternative space pool, Seoul)
My home town
(Boopyung Art center, Inchon)
One and J Gallery, Pierre koenic
(Pierre koenic, L,A, usa)
A positive view

(Sumerset House,Londen, England)
2009 Vague layer and fold (Gallery looks, Seoul)
Dream house (Alternative space pool, Seoul)
Made in Korea (hanover, Germany)
Old dog and Rolling stone (Gallery King, Seoul)
Flare (National Museum of Contemporary Art,
Kimusa branch, Seoul)
The Mark (Gallery Mark, Seoul)
Kim Whan ki International Art Exhibition
(Gallery Iang,Seoul, Germany, Berlin,
Kunstraum)
2008 Metro (Dukwon art Gallery, Seoul)
Wake up (Gallery Now, Seoul)
Trace (One and J Gallery, Seoul)
Metro (Dukwon Gallery, Seou)l
Contemporary Korean Photography 1948-2008
(National Museum of Contemporary Art,
Gwacheon)
B Side (Do Art Seoul, Seoul)
The Prize of Dong-gang Photography Art
(Dong-gang Museum of Photography, Yeongwol)
The Points of the Compass, Sala de Arte Publico
Siqueiros (Mexico City, Mexico, Fundacion
Ludwig de Cuba, Aglutinador Space, Xoho
Gallery, Havana, Cuba)
Pop and Pop (Sungnam Art center, Sungnam)
2007 Asia Art Now (Ssamzi Space, Seou.
Arario Gallery, Peizing)
Suitable Landscape (Space VaVa, Seoul)
Society (Trunk Gallery, Seoul)
Jong Chon Public Art
(Jong Chon-Ri, Choong Nam)
Strange Compass (Gallery Noon, Seoul)

Giants in Illusion (Sejong Art Hall, Seoul)
2006 Pull the trigger (Gallery BB space, Daejeon)
Face of Time, Time of Face
(Art space Hue, Seoul)
Dream of Photography
(Dong-Gang Photo Festival, Yeongwol)
Seoul International Photo Festival (Seoul)
Seoul fringe Festival (Seoul)

Books
2017 Kang, Hong-Goo,
Korean Contemporary Art Book Series
(by Hexagon Publishing Co.,)
2016 Cheongju - City of Seven Villages
(by Wumin Art center)
2015 City We Have Know-Photographs
by Kang Hong Goo & Area Park
(by National Museum of Contemporary Art)
2013 House of Human being- Proxemics Busan
(by Goeun Photo Museum)
2010 Kang, Hong-Goo 1996-2010 (by One & J)
2006 Stroll with Digital Camera
(by Maronie Books)
2000 The beauty of ordinary things
(by Golden branch)
1995 Andy Wahole (publish by Jai Won)
1994 The story of Art, which meet
out of the museum (publish by N,C)

Collection
Busan Municipal Museum of Art (Busan)

Art Seonjae Center (Seoul)
Busan Democratization Park (Busan)
5.18 Momorial Faundation (Kwang ju)
Kcaf Art Center (Seoul)
Muse'e des Biaux-Arts de Tourse (France)
National Modern Art Museum (Kwoa chun)
Samsung Leeum Museum (Seoul)
Hanmi Photograpy Museum (Seoul)
Kyungki-Do Museum (Ansan)
Goeun Photo Museum (Busan)
Woomin Art Center (Chung ju)

Award
2015 The Artist of This Year- Runa Photo Festival
2008 The Prize of Dong-Gang Photography Art
(Dong-Gang)
2006 The Artist of This Year-Visual Art (ARCO)

kaho99@daum.net

HEXAGON 한국현대미술선
Korean Contemporary Art Book